The Seagull Sartre Library

✳

The Seagull Sartre Library

The Seagull Sartre Library

VOLUME 7
ON MODERN ART

JEAN-PAUL SARTRE

TRANSLATED BY
CHRIS TURNER

Seagull
BOOKS

LONDON NEW YORK CALCUTTA

This work is published with the support of
Institut français en Inde – Embassy of France in India

✳

Seagull Books, 2021

ISBN 978 0 8574 2 910 0

British Library Cataloguing-in-Publication Data
A catalogue record for this book is available
from the British Library

Typeset by Seagull Books, Calcutta, India
Printed and bound by Hyam Enterprises, Calcutta, India

CONTENTS

THE QUEST FOR THE ABSOLUTE

Looking at Giacometti's antediluvian face, it does not take long to divine his pride and his desire to place himself at the dawn of the world. Culture he scorns, and he is no believer in Progress either—at least not Progress in the Fine Arts. He sees himself as no more 'advanced' than his adopted contemporaries, the people of Eyzies and Altamira. In those earliest days of nature and humanity, neither ugliness nor beauty existed. Nor taste nor people of taste nor criticism. Everything was still to be done: for the first time it occurred to someone to carve a man from a block of stone.

This was the model, then: the human being. Not being a dictator, a general or an athlete, the human being did not yet have those airs and bedizenments that would attract the sculptors of the future. He was just a long, indistinct silhouette walking across the horizon. But you could already see that his movements were different from the movements of things; they emanated from him like

first beginnings and hinted in the air at an ethereal future. They had to be understood in terms of their purposes—to pick a berry or part a briar—not their causes. They could never be isolated or localized. I can separate this swaying branch from a tree, but never one upraised arm or one clenched fist from a human being. A *human being* raises his arm or clenches his fist: the *human being* here is the indissoluble unit and the absolute source of his movements. And he is, besides, a charmer of signs; they catch in his hair, shine in his eyes, dance on his lips, perch on his fingertips. He speaks with the whole of his body: if he runs, he speaks; if he stops, he speaks; and if he falls asleep, his sleep is speech.

And now here is the material: a rock, a mere lump of space. From space, Giacometti has to fashion a human being: he has to inscribe movement in total stillness, unity in infinite multiplicity, the absolute in pure relativity, the future in the eternal present, the loquacity of signs in the stubborn silence of things. The gap between material and model seems unbridgeable, yet that gap exists only because Giacometti has gauged it. I am not sure whether to see him as a man intent on imposing a human seal on space, or a rock dreaming of the human. Or, rather, he is both these things, as well as the mediation between the two.

The sculptor's passion is to transform himself completely into extension, so that, from the depths of that extension, the whole statue of a man can spurt forth. He

is possessed by thoughts of stone. On one occasion, he felt a terror of the void; for months he walked to and fro with an abyss at his side; that was space becoming aware within him of its desolate sterility. Another time, it seemed to him that objects, drab and dead, no longer touched the ground; he inhabited a floating universe, knowing in his flesh to the point of torture that there is, in extension, neither height nor depth, nor real contact between things. But at the same time he knew the sculptor's task was to carve from that infinite archipelago the complete form of the only being that can *touch* other beings.

I know no one else so sensitive as he to the magic of faces and gestures. He views them with a passionate desire, as though he were from some other realm. But at times, tiring of the struggle, he has sought to mineralize his fellows: he saw crowds advancing blindly towards him, rolling down the avenues like rocks in an avalanche. So, each of his obsessions remained a piece of work, an experiment, a way of experiencing space.

'He's mad,' they will say. 'Sculptors have been working away for three thousand years—and doing it very well—without such fuss. Why doesn't he apply himself to producing faultless works by tried-and-tested techniques, instead of feigning ignorance of his predecessors?'

The fact is that for three thousand years sculptors have been carving only corpses. Sometimes they are called reclining figures and are placed on tombs; sometimes they

are seated on curule chairs or perched on horses. But a dead man on a dead horse does not amount to even half a living creature. They are deceivers all, these stone people of the museum, these rigid, white-eyed figures. The arms pretend to move but are held up by iron rods; the frozen forms struggle to contain an infinite dispersion within themselves. It is the imagination of the spectator, mystified by a crude resemblance, that lends movement, warmth and life here to the eternal deadweight of matter.

So we must start again from scratch. After three thousand years the task of Giacometti and contemporary sculptors is not to add new works to the galleries, but to prove that sculpture is possible. To prove it by sculpting, the way Diogenes, by walking, proved there was movement. To prove it, as Diogenes did against the arguments of Parmenides and Zeno. It is necessary to push to the limits and see what can be done. If the undertaking should end in failure, it would be impossible, in the best of cases, to decide whether this meant that the sculptor had failed or sculpture itself; others would come along, and they would have to begin anew. Giacometti himself is forever beginning anew. But this is not an infinite progression; there is a fixed boundary to be reached, a unique problem to be solved: how to make a man out of stone without petrifying him. It is an all-or-nothing quest: if the problem is solved, it matters little how many statues are made.

'If I only knew how to make one,' says Giacometti, 'I could make thousands . . .'. While the problem

remains unsolved, there are no statues at all, but just rough hewings that interest Giacometti only insofar as they bring him closer to his goal. He smashes everything and begins again. From time to time, his friends manage to rescue a head, a young woman or an adolescent, from the massacre. He leaves them to it and goes back to his work. In fifteen years he has not held a single exhibition. He allowed himself to be talked into this one because he has to make a living, but he remains troubled by it. Excusing himself, he wrote: 'It is, above all, because I was goaded by the terror of poverty that these sculptures exist in this state (in bronze and photographed), but I am not quite sure of them. All the same they were more or less what I wanted. Almost.'

What bothers him is that these moving approximations, still halfway between nothingness and being, still in the process of modification, improvement, destruction and renewal, assumed an independent, definitive existence and embarked on a social career far beyond his control. He is going to forget them. The marvellous unity of this life of his is his intransigence in his quest for the absolute.

This persistent, active worker does not like the resistance of stone, which would slow down his movements. He has chosen for himself a weightless material, the most ductile, the most perishable, the most spiritual: plaster. He can barely feel it beneath his fingertips; it is the intangible counterpart of his movements.

What one notices first in his studio are strange spectres made of white blobs, coagulating around long russet strings. His adventures, ideas, desires and dreams are projected for a moment on to his little plaster men; they give them form and pass on, and the form passes with them. Each of these perpetually changing agglomerations seems to be Giacometti's very life transcribed into another language.

Maillol's statues insolently fling their heavy eternity in our faces. But the eternity of stone is synonymous with inertia; it is the present fixed forever. Giacometti never speaks of eternity, never thinks of it. He said a fine thing to me one day about some statues he had just destroyed: 'I was happy with them, but they were made to last only a few hours.' A few hours: like a dawn, a bout of sadness or a mayfly. And it is true that his figures, being designed to perish on the very night of their birth, are the only sculptures I know that retain the extraordinary charm of perishability. Never was material less eternal, more fragile, more nearly human. Giacometti's material, this strange flour with which his studio is powdered, beneath which it is buried, slips under his nails and into the deep wrinkles of his face; it is the dust of space.

But space, even naked space, is still superabundance. Giacometti has a horror of the infinite. Not the Pascalian infinite, the infinitely large. There is another more insidious, secret infinite that runs through his fingers: the

infinite of divisibility. 'In space,' says Giacometti, there is too much.' This 'too much' is the pure and simple coexistence of juxtaposed elements. Most sculptors have fallen into the trap; they have confused profligacy of extension with generosity, they have put too much into their works; they have delighted in the plump contour of a marble haunch; they have spread human action out, fleshed it out, bloated it.

Giacometti knows there is no excess in a living person, because everything is function. He knows space is a cancer of being that gnaws at everything. For him, to sculpt is to trim the fat from space, to compress it so as to wring all externality from it. The attempt may appear hopeless and, on two or three occasions Giacometti has, I believe, been on the verge of despair. If sculpting means cutting up and stitching together again within this incompressible milieu, then sculpture is impossible. 'And yet,' he said, 'if I begin my statue the way they do, at the tip of the nose, it will take me more than an infinity of time to reach the nostril.' That was when he made his discovery.

Take Ganymede on his pedestal. Ask how far he is from me and I will say I don't know what you're talking about. By 'Ganymede', do you mean the stripling carried off by Jupiter's eagle? If so, I'll say there's no *real* relationship of distance between us, for the very good reason that he does not exist. Or are you referring to the block of marble the sculptor has fashioned in the image of the

handsome youth? If so, we are dealing with something real, with an existing block of mineral, and we can take measurements.

Painters have long understood all this, because, in paintings, the unreality of the third dimension necessarily entails the unreality of the other two. So the distance from the figures to my eyes is *imaginary*. If I step forward, I move nearer not to them but to the canvas. Even if I put my nose to it, I would still see them twenty paces away since for me they exist definitively at a distance of twenty paces. It follows also that painting escapes the toils of Zeno's paradox; even if I divided the space separating the Virgin's foot from Saint Joseph's into two, and split those two halves again and again to infinity, I would simply be dividing a certain length of the canvas, not the flagstones on which the Virgin and her husband stand.

Sculptors did not recognize these elementary truths because they were working in a three-dimensional space on a real block of marble and, though the product of their art was an imaginary man, they thought they were producing it in real space. This confusion of two spaces has had some odd results. First, when they were sculpting from nature, instead of reproducing what they *saw*—that is to say, a model ten paces away—they shaped in clay that which *was* or, in other words, the model in itself. Since they wanted their statue to reproduce for the spectator ten paces away the impression the model had given them, it seemed logical to make a figure that would

be for the spectator what the model had been for them. And that was possible only if the marble was *here* in the same way as the model had been *over there*.

But what does it mean to be *here* and *over there*? Ten paces from her, I form a certain image of this female nude; if I approach and look at her from close up, I no longer recognize her; the craters, crevices, cracks, the rough, black tufts, the greasy streaks, all this lunar orography simply cannot be the smooth fresh skin I was admiring from afar. Is this what the sculptor should imitate? But his task would be endless and, besides, no matter how close he came to her face, it would be possible to get closer.

It follows that the statue will never truly resemble what the model *is* or what the sculptor *sees*. It will be constructed according to certain somewhat contradictory conventions, with some details that are not visible from so far away being shown, on the pretext that they exist, and certain others that exist just as much not being shown, on the pretext that one cannot see them. What does this mean other than that one relies on the eye of the spectator to recompose an acceptable figure? But in that case my relation to Ganymede varies with my position; if near, I will discover details I was unaware of from a distance. And this brings us to the paradox: that I have *real* relations with an illusion or, if you prefer, that my true distance from the block of marble has merged with my imaginary distance from Ganymede.

It follows from this that the properties of true space overlie and mask those of imaginary space. In particular, the real divisibility of the marble destroys the indivisibility of the character represented. Stone triumphs, as does Zeno. Thus, the classical sculptor slides into dogmatism because he believes he can eliminate his own gaze and, without men, sculpt the human nature in man; but, in fact, he does not know what he is making since he does not make what he sees. In seeking the truth, he has found convention. And since, in the end, he shifts the responsibility for breathing life into these inert simulacra on to the visitor, this seeker of the absolute ends up having his work depend on the relativity of the viewpoints from which it is seen. As for the spectator, he takes the imaginary for the real and the real for the imaginary; he searches for the indivisible and everywhere finds divisibility.

By working counter to classicism, Giacometti has restored an imaginary, undivided space to statues. By accepting relativity from the outset, he has found the absolute. This is because he was the first to take it into his head to sculpt human beings as one *sees* them—from a distance. He confers *absolute distance* on his plaster figures just as the painter does on the inhabitants of his canvas. He creates his figure 'ten paces away' or 'twenty paces away' and, whatever you do, that is where it stays. As a result, the figure leaps into unreality, since its relation to you no longer depends on your relation to the block of plaster—art is liberated.

With a classical statue, one must study it or approach it; each moment one grasps new details. The parts become singled out, then parts of the parts and one loses oneself in the quest. You do not approach a Giacometti sculpture. Do not expect this bosom to flesh out as you draw near; it will not change and, as you move towards it, you will have the strange impression of walking on the spot. As for the tips of these breasts, we sense them, divine them, are almost able to see them: one more step, two, and we are still sensing them; another step and everything vanishes. All that remains are puckerings of plaster. These statues can be viewed only from a respectful distance. Yet, everything is there: the whiteness and roundness, the elastic prostration of a fine ripe bosom. Everything except the substance. At twenty paces we feel we can see the wearisome wasteland of adipose tissue. But we cannot: it is suggested, outlined, signified, but not given.

We now know what press Giacometti used to condense space. There is only one: distance. He puts distance within reach. He pushes a distant woman before our eyes—and she keeps her distance even when we touch her with our fingertips. That breast we glimpsed and hoped to see will never spread itself before us; it is merely a hope. These bodies have only as much substance as is required to hold forth a promise. 'Yet that's not possible,' someone might say. 'The same object can't at the same time be viewed close up and from afar.' Hence it is not the same object. It is the block of plaster

that is near; it is the imaginary person that is far away. 'Distance should at least, then, effect its contraction in all three dimensions. But it is breadth and depth that are affected; height remains intact.' This is true. But it is also true that human beings possess absolute dimensions for other human beings. If a man walks away from me, he does not seem to grow smaller, but his qualities seem rather to condense while his 'bearing' remains intact. If he draws near to me, he does not grow larger, but his qualities open out.

Yet we must admit that Giacometti's men and women are closer to us in height than in width—as though they were taller than they should be. But Giacometti has elongated them deliberately. We must understand, in fact, that one can neither *learn* to know these figures, which are what they are wholly and immediately, nor observe them. As soon as I see them, I know them. They burst into my visual field like an idea in my mind. Ideas alone have this immediate translucency and are at a stroke what they are. Thus. Giacometti has in his way solved the problem of the unity of the multiple: he has quite simply suppressed multiplicity.

The plaster and the bronze are divisible, but this woman walking has the indivisibility of an idea or a feeling; she has no parts because she yields herself up all at once. It is to give tangible expression to this pure presence, to this gift of self, this instantaneous emergence, that Giacometti resorts to elongation.

The original movement of creation—that timeless, indivisible movement so beautifully figured in the long, gracile legs—runs through these El Greco-like bodies and lifts them heavenward. In them, even more than in one of Praxiteles' athletes, I recognize Man, the first beginning, the absolute source of the act. Giacometti has succeeded in imparting to his material the only truly human unity—unity of action.

This is the kind of Copernican revolution he has tried to introduce into sculpture. Before him, artists thought they were sculpting *being*, and that absolute dissolved into an infinity of appearances. He chose to sculpt *situated* appearance and it turned out that one reached the absolute that way. He gives us men and women *already seen*. But not already seen by himself alone. These figures are already seen in the way that a foreign language we are trying to learn is already spoken. Each of them shows us the human being as he *is seen*, as he is for other human beings, as he emerges in an interhuman milieu— not, as I said earlier for the sake of simplification, ten or twenty paces away, but at a human distance from us. Each imparts to us the truth that man is not there primarily in order subsequently to be seen, but is the being whose essence is to exist for others. When I look at this plaster woman, it is my cool gaze I encounter in her. Hence the pleasant sense of unease which the sight of her occasions. I feel constrained and know neither why nor by whom until I discover that I am constrained to see and constrained by myself.

Giacometti often takes pleasure, in fact, in adding to our perplexity—for example, by putting a distant head on a nearby body, so that we no longer know where to place ourselves or literally how to focus. But even without this these ambiguous images are disconcerting, so much do they clash with our most cherished visual habits. We were accustomed for so long to smooth, mute creatures, made to cure us of the sickness of having a body; these guardian spirits watched over our childhood play and attest, in our parks and gardens, to the fact that the world is risk-free, that nothing ever happens to anyone and hence that nothing has ever happened to them except dying at birth.

Now, to *these* bodies something has happened. Do they come from a concave mirror, a fount of eternal youth or a concentration camp? At first glance, we seem to be dealing with the emaciated martyrs of Buchenwald. But a moment later we have changed our minds: these slim, lissom creatures rise heavenward and we chance on a whole host of Ascensions and Assumptions; they dance, they *are* dances, made of the same rarefied substance as the glorious bodies promised to us by Scripture.1 And while we are still contemplating this mystical elan, suddenly these emaciated bodies blossom and before us we have merely earthly flowers.

The martyred creature was merely a woman. But she was *all* of a woman—glimpsed, furtively desired, as she

1 *Corps glorieux.* The reference is to Philippians 3:21. [Trans.]

moved off and passed by with the comic dignity of those leggy, helpless, fragile girls whom high-heeled mules carry lazily from bed to bathroom with all the tragic horror of the hunted victims of fire or famine; all of a woman—given, rejected, near, remote; all of a woman, her delicious plumpness haunted by a secret slimness, and her atrocious slimness by a suave plumpness; all of a woman—in danger on the earth and no longer entirely on the earth, who lives and tells us the astounding adventure of flesh, *our* adventure. For, like us, she chanced to be born.

Yet Giacometti is not happy. He could win the game right away, simply by deciding he has won. But he cannot make his mind up to do so. He postpones his decision from hour to hour, from day to day. Sometimes, in the course of a night's work, he is on the point of admitting his victory; by morning, all is shattered. Does he fear the boredom that awaits him on the other side of triumph, that boredom that beset Hegel after he had imprudently rounded off his system? Or perhaps matter is taking its revenge? Perhaps that infinite divisibility he expelled from his work is being endlessly reborn between himself and his goal. The end is in sight: to reach it, he has to do better. And he does so, but now he has to do *a little* better still. And then *just a tiny bit* better. This new Achilles will never catch up with the tortoise. A sculptor has, one way or another, to be the chosen victim of space—if not in his work, then in his life. But above all, between him and us, there is a difference of position.

He knows what he was trying to do and we do not; but we know what he has done and he does not. These statues are still more than half embedded in his flesh. He cannot see them. He has barely finished them and he is off dreaming of even thinner, even longer, even lighter women and it is thanks to his work that he conceives the ideal against which he judges that work imperfect. He will never be done with it, merely because a man is always beyond what he does. 'When I finish,' he says, 'I'll write, I'll paint, I'll enjoy myself.' But he will die before he finishes.

Are *we* right or is *he*? To begin with, he is right because, as Da Vinci said, it is not good for an artist to be happy. But we are right too—and right in the last instance. As he lay dying, Kafka asked to have his books burnt and Dostoevsky, in the very last stages of his life, dreamed of writing a sequel to *The Brothers Karamazov*. Both may have died in poor spirits, the former thinking he would slip from the world without even having scratched its surface, the latter feeling he had produced nothing of value. And yet both were winners, whatever they might have thought.

Giacometti is also a winner, and he is well aware of it. In vain does he hang on to his statues like a miser with his pot of gold; in vain does he procrastinate, temporize and find a hundred ruses for stealing more time. People will come into his studio, brush him aside and carry away all his works—even the plaster that covers his floor.

He knows this. His hunted air betrays him. He knows that he has won in spite of himself, and that he belongs to us.

Les Temps modernes (January 1948)

✷

CALDER'S MOBILES

If it is true that the sculptor is supposed to infuse static matter with movement, then it would be a mistake to associate Calder's art with the sculptor's. Calder does not suggest movement, he captures it. It is not his aim to entomb it forever in bronze or gold, those glorious, stupid materials doomed by their nature to immobility. With cheap, flimsy substances, with little bones or tin or zinc, he makes strange arrangements of stalks and palm leaves, of discs, feathers and petals. They are resonators, traps; they dangle on the end of a string like a spider at the end of its thread, or are piled on a base, lifeless and self-contained in their false sleep. Some errant tremor passes and, caught in their toils, breathes life into them. They channel it and give it fleeting form—a *Mobile* is born.

A Mobile: a little local *fiesta*; an object defined by its movement and non-existent without it; a flower that withers as soon as it comes to a standstill; a pure stream

of movement in the same way as there are pure streams of light. Sometimes Calder amuses himself by imitating a new form. He once gave me an iron-winged bird of paradise. It takes only a little warm air to brush against it as it escapes from the window and, with a little click, the bird smoothes its feathers, rises up, spreads its tail, nods its crested head, rolls and pitches and then, as if responding to an unseen signal, slowly turns right around, its wings outspread. But most of the time he imitates nothing, and I know no art less untruthful than his.

Sculpture suggests movement, painting suggests depth or light. Calder suggests nothing. He captures true, living movements and crafts them into something. His mobiles signify nothing, refer to nothing other than themselves. They simply *are*: they are absolutes.

In his mobiles, the 'devil's share' is probably greater than in any other human creation.[1] The forces at work are too numerous and complicated for any human mind, even that of their creator, to be able to foresee all their combinations. For each of them Calder establishes a general fated course of movement, then abandons them to it: time, sun, heat and wind will determine each particular dance. Thus the object is always midway between the servility of the statue and the independence of natural events. Each of its twists and turns is an inspiration

1 *La part du diable* may be said to be everything that eludes understanding. It is the title of a 1942 work by Denis de Rougement. [Trans.]

of the moment. In it you can discern the theme composed by its maker, but the mobile weaves a thousand variations on it. It is a little hot-jazz tune, unique and ephemeral, like the sky, like the morning. If you missed it, it is lost forever.

Valéry said the sea is always beginning over again. One of Calder's objects is like the sea and just as spellbinding: always beginning over again, always new. A passing glance is not enough; you must live with it, be bewitched by it. Then the imagination revels in these pure, interchanging forms, at once free and rule-governed.

These movements that intend only to please, to enchant our eyes, have nonetheless a profound and, as it were, metaphysical meaning. This is because the mobiles have to have some source of mobility. In the past, Calder drove them with an electric motor. Now he abandons them in the wild: in a garden, by an open window he lets them vibrate in the wind like Aeolian harps. They feed on the air, breathe it and take their life from the indistinct life of the atmosphere. Their mobility is, then, of a very particular kind. Though they are human creations, they never have the precision and efficiency of de Vaucanson's automata. But the charm of the automaton lies in the fact that it handles a fan or a guitar like a human being, yet its hand movements have the blind, implacable rigour of purely mechanical translations. By contrast, Calder's mobiles waver and hesitate. It is as though they make an error, then correct it.

I once saw a beater and gong hanging very high up in his studio. At the slightest draught of air, the beater went after the rotating gong. It would draw back to strike, lash out at the gong and then, like a clumsy hand, miss. And just when you were least expecting it, it would come straight at it and strike it in the middle with a terrible noise. These movements are too artistically contrived to be compared to those, say, of a marble rolling on a rough plane, whose course depends solely on the uneven terrain: the movements of Calder's mobiles have a life of their own.

One day, when I was talking with Calder in his studio, a mobile, which had until then been still, became violently agitated right beside me. I stepped back and thought I had got out of its reach. But suddenly, when the agitation had left it and it seemed lifeless again, its long, majestic tail, which until then had not moved, came to life indolently and almost regretfully, spun in the air and swept past my nose.

These hesitations and resumptions, gropings and fumblings, sudden decisions and, most especially, marvellous swan-like nobility make Calder's mobiles strange creatures, mid-way between matter and life. At times their movements seem to have a purpose and at times they seem to have lost their train of thought along the way and lapsed into a silly swaying. My bird flies, floats, swims like a swan, like a frigate. It is one, one single bird. And then, suddenly, it breaks apart and all that remain are rods of metal traversed by futile little tremors.

These mobiles, which are neither entirely alive nor wholly mechanical, constantly disconcerting but always returning to their original position, are like aquatic plants swaying in a stream; they are like the petals of the *Mimosa pudica*, the legs of a decerebrate frog or gossamer threads caught in an updraft.

In short, although Calder has not sought to imitate anything—there is no will here, except the will to create scales and harmonies of unknown movements—his mobiles are at once lyrical inventions, technical, almost mathematical combinations and the tangible symbol of Nature, of that great, vague Nature that squanders pollen and suddenly causes a thousand butterflies to take wing, that Nature of which we shall never know whether it is the blind sequence of causes and effects or the timid, endlessly deferred, rumpled and ruffled unfolding of an Idea.

From the catalogue
for a Calder exhibition, 1946

<div align="center">✳</div>

GIACOMETTI'S PAINTINGS[1]

'Several naked women, seen at the Sphinx, as I am sitting at the back of the room. The distance separating us (the shiny floor that seemed impassable despite my desire to cross it) impressed me as much as did the women.'[2] The result: four inaccessible figurines, balanced on a massive wave that is, in fact, a vertical floor. He made them as he saw them—*distant*. But here are four tall girls with a substantial *presence,* surging up from the ground and about to crash down on him, all together, like the lid of a box: 'I saw them often, particularly one evening, in a little room on the rue de l'Échaudé, very close and threatening.' In his eyes, distance, far from being an accident, is part of the intimate nature of the object. These whores twenty—impassable—yards away are forever fixed in the glare of his hopeless desire. His studio is an archipelago,

1 On an exhibition of Giacometti's paintings at the Galérie Maeght. [Ed.]

2 Letter to Matisse (November 1950).

a disorder of diverse distancings. Against the wall, the Mother-Goddess retains the nearness of an obsession; if I retreat, she advances; she is closest when I am most distant. This statuette at my feet is a passer-by glimpsed in the rear-view mirror of a car, disappearing from sight. It's no use my approaching; he keeps his distance.

These solitudes push the visitor back the whole insuperable length of a room, a lawn or a glade that one has not dared to cross; they attest to the strange paralysis that grips Giacometti at the sight of his fellow creatures. Not that he is misanthropic: the torpor is the effect of a surprise mixed with fear, often with admiration and sometimes with respect. He is, admittedly, distant. But, after all, it was man who created distance and it has meaning only within a human space; it separates Hero from Leander and Marathon from Athens, but not one pebble from another pebble. I understood what it was one April evening in 1941: I had spent the previous ten months in a POW camp or, in other words, in a sardine tin, and had experienced absolute proximity there. The boundary of my living space was my skin; day and night I had felt the warmth of someone's side or shoulder against me. This was no great annoyance: the others were still me. On this first evening of freedom, as a stranger in my native town and not yet having met up with my old friends, I pushed open the door of a cafe. Suddenly, I was afraid—or almost. I couldn't understand how these squat, bulbous buildings could conceal such deserts within them. I was lost: the few drinkers seemed more

distant than the stars; each of them had a great area of seat to himself, a whole marble table, and to touch them, I would have had to have crossed the 'shiny floor' that separated me from them. If they seemed inaccessible to me, these men shimmering comfortably in their tubes of rarefied gas, it was because I no longer had the right to put my hand on their shoulders or their thighs and call them 'kiddo'. I was back in bourgeois society; I had to re-learn life 'at a respectable distance' and my sudden agoraphobia betrayed my vague sense of regret for the 'unanimous' life from which I had just been definitively separated.[3]

So it is with Giacometti: in his work distance isn't a voluntary isolation, nor even a stepping back: it is a demand, a ceremony, a sense of difficulties. It is the product—he has said so himself[4]—of the forces of attraction and repulsion. If he cannot cross these few metres of shiny floor separating him from the naked women, that is because shyness or poverty keep him rooted to his chair; but if he feels so much that those few metres are uncrossable, this is because he wants to touch the sumptuous flesh. He refuses to mingle and rejects relations of good neighbourliness, because he wants friendship and love. He does not dare to take, because he is afraid of being taken.

3 This would seem to be a reference to the 'unanimism' of Jules Romains, a doctrine initially presented as an antidote to modern individualism, though later refined somewhat. [Trans.]

4 Letter to Matisse (November 1950).

His figurines are solitary, but if you put them together in any way at all, their solitude unites them; they suddenly form a little magical group: 'Looking at the figures, which, to clear the table, had been placed randomly on the ground, I noticed that they formed two groups which seemed to match what I was looking for. I mounted the two groups on bases without the slightest change . . .' A Giacometti exhibition is a populace. He has sculpted people crossing a public square but not seeing one another; they pass each other by, irremediably alone, and yet *they are together*: they are going to be lost forever, but they would not be lost if they had not sought each other. He defined his universe better than I could when he wrote of one of his groups that it reminded him of, 'a corner of a forest seen over many years, whose trees, with their slender, bare trunks . . . always seemed to be like people halted in their tracks and talking to each other.' And what is this circular distance—which speech alone can cross—but the negative notion, *the void*? Ironic, wary, ceremonious and affectionate, Giacometti sees emptiness everywhere. Not everywhere, you will say. There are objects that touch. But this is the point: Giacometti is sure of nothing; not even of that. He was fascinated for weeks by the feet of a chair: they did not *touch* the ground. Between things, between people, the bridges are broken; emptiness slips in everywhere, each creature secretes its own void.

Giacometti became a sculptor because he is obsessed with emptiness. One statuette he called 'Me rushing

along a street in the rain'.[5] Sculptors seldom make busts
of themselves; if they attempt a 'portrait of the artist',
they look at themselves from the outside, in a mirror:
they are prophets of objectivity. But imagine a lyrical
sculptor: what he wants to convey is his inner feeling,
that boundless void that grips him and separates him
from shelter, his abandonment to the storm. Giacometti
is a sculptor because he carries his void the way snails
carry their shells, because he wants to convey this in all
its facets and in all dimensions. And sometimes he gets
on well with the tiny state of exile he carries with him
everywhere, and sometimes he is horrified by it.

A friend moves in with him: Giacometti, happy at
first, quickly begins to worry: 'In the morning, I open
my eyes: he had his trousers and his jacket *on my empty
space.*' At other times, however, he keeps tight to the
walls, clings to them: the void around him portends fall,
landslip or avalanche. In any event, he must bear witness
to it.

Will sculpture alone be able to do this? As the figure
leaves his fingers, it is 'ten paces away', 'twenty paces
away' and, whatever you do, it stays there. It is the statue
itself that determines the distance from which you must
see it, just as court etiquette determines the distance
from which you must address the king. The *real* engen-
ders the no-man's-land that surrounds it. A Giacometti

5 The New York Museum of Modern Art lists this work, rather
strangely, as 'Walking Quickly Under [*sic*] the Rain' (1949). [Trans.]

figure is Giacometti himself producing his little local nothingness. But all these tiny absences, which belong to us the way our names or our shadows do, are not enough to make a world. There is also the Void, that universal distance of everything from everything else. The street is empty, in the sun: and *in this void* a person appears suddenly. Sculpture *sets out from fullness* to create emptiness: can it show fullness emerging in the midst of a former emptiness? Giacometti has tried to answer this question a hundred times. His composition *The Cage* represents 'his desire to abolish the base and to have a *limited* space for creating a head and a figure.' This is the whole problem: the—immemorial—void will always predate the beings that populate it if it is first enclosed between walls. This 'Cage' is 'a room I saw, I even saw curtains behind the woman . . .' Another time, he makes 'a figurine in a box between two boxes that are houses'. In short, he frames his figures: with regard to us, they retain an imaginary distance, but they live in a closed space that imposes its own distances on them, in a prefabricated void which they do not manage to fill and do not create, but submit to. And what is this framed, populated void if not a picture? Lyrical when he is sculpting, Giacometti becomes objective when he paints: he attempts to pin down the features of Annette or Diego as they appear in an empty room, in his deserted studio.

I have tried to show elsewhere that he came to sculpture like a painter, since he handled a plaster figurine as though it were a figure in a painting: he confers a fixed,

imaginary distance on his statuettes. Conversely, I can say that he approaches painting as a sculptor, for he would like us to see the imaginary space delimited by the frame as a *genuine* void. He would like us to see the seated woman he has just painted through several layers of emptiness; he would like the canvas to be like still water and us to see his figures *in* the picture the way Rimbaud saw a drawing-room in a lake—showing through it.[6] Sculpting the way others paint and painting the way others sculpt, is he a painter? Is he a sculptor? He is neither. And both. He is a painter and a sculptor because the age will not allow him to be a sculptor and an architect. As a sculptor in order to restore everyone's circular solitude and a painter in order to put men and things back into the world—that is to say into the great universal Void— it so happens that he sometimes models what he initially wanted to paint.[7] But on other occasions he knows that sculpture (or, alternatively, painting) alone enables him to 'realize his impressions'. At any rate, the two activities are inseparable and complementary: they enable him to treat the problem of his relations with other people in all its aspects, according to whether the distance comes from them, from him or from the universe.

How can you paint emptiness? Before Giacometti no one seems to have tried. For five hundred years,

6 In Arthur Rimbaud, 'Délires II', *Une saison en enfer* (1873); 'A Season in Hell' (Louise Varèse trans.), in *A Season in Hell and The Drunken Boat* (New York: New Directions, 1952). [Trans.]

7 For example, *Nine Figures* (1950).

paintings have been packed to the gunwales; the whole world has been crammed into them. Giacometti begins by expelling people from his canvases: his brother Diego, all alone, lost inside a great shed, is sufficient. And this character still has to be distinguished from the things around him. Normally, this is done by emphasizing his outline. But a line is produced by the intersection of two surfaces, and emptiness cannot count as a surface. Even less can it count as a volume. You separate the container from the content by means of a line: but emptiness isn't a container. Can we say that Diego 'stands out against' this dividing wall behind him? We cannot: the 'figure/ground' relation exists only for relatively flat surfaces; unless he leans against it, this distant wall cannot 'serve as a background' to Diego; when all is said and done, he has no connection with it whatever. Or rather, he has: since man and object are in the same picture, there have to be some appropriate relationships (colours, values, proportions) that confer unity on the painting. But these correspondences are simultaneously erased by the noth-ingness that interposes itself between them. No, Diego does not stand out against the grey background of a wall; he is there and the wall is there—and that is all there is to it. He is not enclosed or supported or contained by anything: he *appears* all alone in the immense frame of emptiness. With each of his pictures, Giacometti takes us back to the moment of creation *ex nihilo*. Each of them raises again the old metaphysical question, 'Why is there something rather than nothing?' And yet there

is something: there is this stubborn, unjustifiable, supererogatory apparition. This painted figure is mind-boggling because he is presented in the form of an *interrogative apparition.*

But how is he to be pinned down on the canvas without putting some sort of line around him? Is he not going to burst in the void like a fish from the abyssal depth brought up to the surface of the water? Indeed he is not: the line represents an arrested flight; it marks a balance between outside and inside; it forms around the shape the object adopts under pressure from outside forces; it is a symbol of inertia, of passivity. But Giacometti doesn't regard finitude as a limitation imposed upon him: the coherence of the real, its plenitude and its determination are one single effect of its inner affirmative power. 'Apparitions' both affirm and limit themselves as they take on definition. Like those strange curves studied by mathematicians that are both encompassing and encompassed, the object is its own envelope.

One day, when he had set out to draw me, Giacometti exclaimed in astonishment: 'What density, what lines of force!' And I was even more astonished than he was, since I believe I have, like everyone, a rather flabby face. But he saw every feature as a centripetal force. The face coils back on itself, it is a loop closing. Move round it and you will never find an outline: only fullness. Lines are the beginnings of negation, the transition from being to non-being. But Giacometti sees the

real as pure positivity: *there is* being, and then, suddenly, there no longer is: but from being to nothingness no transition is conceivable. Observe how the many lines he traces are *internal* to the form he is describing; see how they represent the intimate relations of being with itself: folds in a jacket, wrinkles in a face, the protrusion of a muscle, the direction of a movement. All these lines are centripetal: their aim is to pull things tighter, they force the eye to follow them and bring it back always to the centre of the figure; you would think the face were retracting under the influence of some astringent substance: in a few minutes it will be the size of a fist or a shrunken head. And yet the limit of the body is nowhere marked: sometimes the heavy mass of flesh ends obscurely, stealthily, in a vague brown nimbus, somewhere beneath the tangle of lines of force—and sometimes it literally has no end: the outline of the arm or hip is lost in a shimmering of light that conjures it away. Without warning, we are made to watch a sudden dematerialization: here is a man crossing his legs; so long as I focussed only on his head and shoulders, I was convinced he had feet; I even thought I could see them. But if I look at them, they unravel; they fade into luminous mist and I no longer know where body ends and void begins. And don't go thinking this is one of those disintegrations that Masson attempted, so as to give objects a kind of ubiquity by spreading them all over the canvas. If Giacometti didn't delimit the shoe, that wasn't because he believed it to be limitless but because he's counting

on us to supply a limit. And in fact the shoes are there, heavy and dense. To see them you simply have not quite to look at them.

To understand this technique, let us examine the sketches he sometimes makes of his sculptures. Four women on a base: well and good. Now let's look at the drawing. Here is a head and a neck, drawn with full strokes, then nothing, then nothing, then an open curve revolving around a point: the belly and the navel. Here again is the stump of a thigh, then nothing, then two vertical lines and, lower down, two others. This is all. The whole of a woman. What have we done here? We have used our knowledge to re-establish continuity and our eyes to stick these *disjecta membra* together: we *saw* shoulders and arms on the blank paper; we saw them because we had *recognized* the head and the belly. And these limbs were there in fact, even though no lines supplied them. In the same way we sometimes conceive lucid, fully-formed ideas though no words supply them to us. Between the two extremities, the body is a shooting current. We are confronted with the pure real, the invisible tension of the blank paper. But isn't the void also represented by the whiteness of the paper? Precisely: Giacometti rejects both the inertia of matter and the inertia of pure nothingness. Emptiness is fullness relaxed and spread-out; fullness is oriented emptiness. The real flashes like lightning.

Have you noticed the profusion of white lines scoring the torsos and faces? This Diego isn't solidly stitched:

he's simply basted together as the dressmakers say. Or might it be that Giacometti wants to 'write luminously on a dark background'? Almost. It's no longer a matter of separating fullness from the void but of painting plenitude itself. Now, plenitude is both singular and diverse: how can it be differentiated without being divided? Black strokes are dangerous: there's a danger they will efface being or fissure it. If we use them to outline an eye or encircle a mouth, we shall be exposed to the belief that there are little pockets of emptiness within reality. These white striations are there as inconspicuous indications: they guide the eye, force it to move in a particular way, then melt beneath our gaze. But the real danger lies elsewhere. We know how successful Arcimboldo was, with his heaps of vegetables and piles of fish. What is it that appeals to us in these trick images? Might it be the fact that this is a technique we have long been familiar with? What if our painters were all, in their way, Arcimboldos? They would not, admittedly, stoop to making a human head out of a pumpkin and some tomatoes and radishes. But do they not each day make faces with a pair of eyes, a nose, two ears and thirty-two teeth? What is the difference? To take a sphere of pink flesh, make two holes in it and ram an enamelled marble into each hole; to shape a nasal appendage and plant it, like a false nose, beneath the eye sockets; to pierce a third hole and fill it with white pebbles—isn't this precisely to replace the indissoluble unity of a face with a jumble of heteroclite objects? Emptiness seeps in everywhere; between the eyes

and the eyelids, between the lips, into the nostrils. A head becomes an archipelago in its turn. You may say that this strange assemblage corresponds to reality, that the oculist can remove eyes and the dentist can extract teeth? Perhaps. But what should painters paint? That which is? That which we see? And what do we see? Some painters have depicted this chestnut tree beneath my window as a great, self-contained, quivering ball; others have painted its leaves one by one, with the veins showing. Do I see a leafy mass or a multitude of leaves? Individual leaves or foliage? Heaven knows, I see both; it's neither entirely the one nor the other; and I am tossed endlessly from the one to the other. As regards the leaves, I do *not* see them right to the end; I think I am going to apprehend them all, but then I lose them. And when I can hold the foliage in view, it breaks up into leaves. In short, I see a teeming coherence, a dispersion folded back on itself. Try painting that!

And yet Giacometti wants to paint what he sees, just as he sees it. He wants his figures, each set in their original voids on his static canvas, perpetually to move from the continuous to the discontinuous. He wants the head to be isolated, since it rules the body, but he wants the body to reclaim it, so that it is merely a periscope of the belly, in the same way as Europe is described as being a peninsula of Asia. He wants the eyes, the nose and the mouth to be leaves in a leafy mass, at once separate and merged together. And he manages to do it: this is his great achievement. How? By refusing to be more precise

than perception. It isn't a question of painting *vaguely*; on the contrary, he will suggest a perfect precision of being beneath the imprecision of knowing. In themselves, or for others with better eyesight—for angels— these faces conform rigorously to the principle of individuation; they are determined down to the tiniest detail. We know this at first glance: moreover, we immediately recognize Diego and Annette. This alone, if such a thing were needed, would absolve Giacometti of the charge of subjectivism. But at the same time we cannot view the canvas without unease: despite ourselves, we want to ask for a torch or, quite simply, a candle. Is there a mist, or is evening falling, or are our eyes getting tired? Is Diego lowering or raising his eyelids? Is he dozing? Is he dreaming? Is he peeping?

Of course we ask these same questions at an exhibition of bad paintings, when faced with some poor portrait done so hazily that all answers are possible without any particular one requiring our assent. But that clumsy indeterminacy bears no relation to Giacometti's calculated indeterminacy: and indeed, should we not better term the latter over-determinacy? I turn to Diego and, from one moment to the next, he is sleeping, awake, looking at the sky and then staring at me. All these things are true and all are clear: but, if I bend my head a little and change the angle of my gaze, the obvious truth vanishes and is replaced by another. If, wearying, I want to settle on one single opinion, I have no recourse but to leave as quickly as I can. Even then, it will still be

only fragile and probable: for example, when I find a face in the fire, an inkblot or a swirl of drapery, that shape, emerging suddenly, tautens and forces itself upon me. Yet, though *I* cannot see it differently, I know others will. But the face in the flames has no truth to it: what irritates and at the same time enchants us in Giacometti's pictures is *that there is* a truth and we are sure of it. It is there, within my grasp, if only I search it out. But my vision blurs, my eyes tire and I give up. Particularly as I am beginning to understand: Giacometti has us in his grasp because he has stood the problem on its head.

Take a painting by Ingres. If I look at the tip of the Odalisque's nose, the rest of the face becomes blurred, a pink butter, flecked with a delicate red by the lips. Now, if I turn my gaze on the lips, they will come out of the shadow, moist and parted, and the nose will disappear, consumed by the lack of differentiation of the background. But no matter: reassuringly, I know I can conjure it up again at will. With Giacometti, the opposite is the case: for a detail to seem clear and reassuring, I have—I have only—not to make it the explicit object of my attention; what inspires confidence is what I glimpse out of the corner of my eye. The more I observe Diego's eyes, the less able I am to decipher them; but I can sense slightly sunken cheeks and a strange smile playing about the corners of his mouth. If my unhappy taste for certainty leads my eyes down to that mouth, everything immediately eludes me. What is it like? Hard? Bitter? Ironic? Open? Pursed? His eyes, on the other hand, have

almost passed out of my visual field and I now *know* they are half-closed. And there is nothing to stop me from moving on further, obsessed by this phantom face that is perpetually forming, unforming and re-forming behind me. The remarkable part is that you believe in it. As in hallucinations: in the beginning you glimpse them from one side and, when you turn around, they are gone. Ah, but on the other side . . .

Are these extraordinary figures—so perfectly immaterial that they often become transparent, and so totally, fully real that they hit you unforgettably like a physical blow—in the process of appearing or disappearing? They are doing both at the same time. They seem so diaphanous at times that we no longer even dream of enquiring about their faces: we pinch ourselves to find out if they really exist. If we persist in staring at them, the entire picture comes to life: a dark sea surges over and submerges them; nothing remains but a surface smeared with soot; and then the wave rolls back and we see them again, white and naked, shining beneath the waters. But when they reappear, it is with a violent affirmation, like muffled cries that reach the top of a mountain and which we know, when we hear them, have somewhere been shouts for help or cries of pain. This play of appearance and disappearance, of flight and provocation lends them a certain coquettish air. They remind me of Galatea, who fled from her lover beneath the willow trees and, at the same time, wanted him to see her. Coquettish, yes, and graceful, since they are all

action, and sinister because of the void that surrounds them, these creatures of nothingness attain to the fullness of existence by escaping our clutches and mystifying us. Every evening an illusionist has three hundred accomplices: the spectators themselves and their second natures. He attaches a wooden arm to his shoulder in a fine red sleeve. The audience asks of him two arms in sleeves of identical material. It sees two arms and two sleeves and is contented. Meanwhile, an unseen real arm, wrapped in black material, will pull out a rabbit, a playing card or an exploding cigarette. Giacometti's art is akin to the prestidigitator's: we are his dupes and his accomplices. Without our eagerness, our thoughtless haste, the traditional unreliability of our senses and the contradictions of our perception, he would not succeed in bringing his portraits to life. He works 'by eye', from what he sees, but especially from what he believes we will see. It is not his aim to present us with an image, but to produce simulacra which, while presenting themselves as what they are, arouse feelings and attitudes in us that are normally produced by encounters with real human beings.

At the Musée Grévin, you may either be irritated or frightened when you mistake a waxwork figure for the museum attendant. Nothing could be easier than to weave elaborate practical jokes on this theme. But Giacometti doesn't particularly like jokes. Except for one. One single practical joke to which he has dedicated his life. He understood many years ago that artists work

in the imaginary realm and we create only illusions; he knows that the 'monsters imitated by art' will never produce anything but factitious fears among spectators. Yet he has not lost hope: one day he will show us a portrait of Diego that is in appearance just like the others. We shall be forewarned; we shall know it is merely a fantasy, a vain illusion, captive within its frame. And yet on that day, as we stand before the mute canvas, we shall feel a shock—a tiny shock. The same shock we feel when we are coming home late and a stranger comes towards us in the dark; then Giacometti will know that he has, by his paintings, given rise to a real emotion, and that his simulacra, while remaining illusory, will, for a few moments, have had *genuine* powers. I wish him success in pulling off this memorable practical joke soon. If he doesn't manage it, that will be because no one can. In any event, no one can go further.

Les Temps modernes, 103
(June 1954)

✳

THE UNPRIVILEGED PAINTER

Since Goya's time, killers have gone on with their slaughter and right-thinking souls with their protests. Every five or ten years, a painter comes along and updates *Disasters of War* by modernizing the uniforms and the weaponry. Without success: there can be no doubting the indignation in the painter's heart, but it doesn't transmit itself to the brush.

Lapoujade's undertaking is of a quite different order.[1] His aim is not to fix art in some set form by subordinating it to the needs of Good Intentions, but to interrogate painting *from the inside* about its movement and its scope. Since the point almost a century ago when creation became a critical endeavour, it has been audacious, and has examined its own audacity and judged it. Lapoujade, drawn along by the developments in Painting that he himself has effected, has been led to bestow presences on us that are both at the heart of each composition and beyond them all. Figurative art wasn't appropriate for

manifesting these presences: the human figure, in particular, concealed men's suffering. It has disappeared now and, in the very fabric of art, something has been born from its death: tortured victims, flattened cities, massacred crowds; the torturers, too, are present everywhere. Victims and persecutors—the painter has painted our portrait. The portrait of the century. At the same time, the object of his art is no longer the individual. Nor the typical. It is the singularity of an age and its reality. How has Lapoujade, obeying the very demands of 'abstraction', achieved what the figurative has never managed to pull off?

Since pictures won the freedom to subject themselves to the laws of Painting alone, the artist has been able to reassert the fundamental, inviolable bond between his work and Beauty. Whatever its origin, a picture will either be beautiful or will not exist at all; when a canvas has simply been daubed with paint, painting has not taken place, and that is all there is to it. In that case, the eye sees only a daub. The Beautiful is not even the goal of art: it is its flesh and blood, its being. Everyone has always said this and everyone claims to know it. All well and good. But it is true, nonetheless, that this pure fundamental concern, concealed at the beginning of the century by an alchemist's dream—the desire to produce a real absolute—is rediscovering its primal purity in abstract art. As a result, the old 'Art for Art's sake' chestnut has returned with vigour: yet how silly it is! For no one 'makes art' merely for the sake of doing

so, or in order that Art should exist. People simply make art and that is all there is to it. Lapoujade doesn't paint his canvases in the hope of adding a few square inches to the surface area of Beauty. But he will derive his motifs, themes, obsessions and purposes from the very movement of his art: when the world of the plastic arts has dissolved its figurative constraint, what exigencies will sustain its continued existence? It must be said that all the works we see here have no other source: Lapoujade's *Hiroshima* was called forth *by Art*.

Some will find this shocking. It is a long time since politicians first got into the habit of asking little favours from artists. Beribboned renegades long ago proved that painting dies the moment it is made to serve alien purposes. Up until now, in fact, if painters wanted to depict man's inhumanity to man, they were suddenly faced with this unfortunate alternative: they could either betray painting without any great gain for Morality or if, despite everything, their work seemed beautiful, they could betray men's suffering and anger to Beauty. There was betrayal at every turn.

Fine sentiments incline a painter towards academicism. If you wish to communicate a legitimate indignation to the public, that public has above all to be able to decipher the message; the disquieting aspects of art will, in that case, be subordinated to its false securities. Living Beauty is always a work in progress: so as not to perplex the public with experimentation, the artist will choose a dead form; the most readable style will be adopted,

which is necessarily an old one that has become conventional. As for showing torture, bodies with torn flesh, living bodies racked, tormented and burned, some have tried it but they have not, I think, repeated the experiment. In fact, reawakening our visual habits, they have presented us with the disturbing imitation of reality and inclined us, as a result, to react as we would in reality—with horror, anger and, above all, with that silent sympathy that causes every human being to feel the wounds of others as so many gaping holes in his own body. An unbearable spectacle and one that drives the spectator away. After that, the painting may be an ingenious composition, with carefully judged proportions and harmony, but that is of little consequence since we have already fled and shall not return. And if we were to return, the punctured eyes and scabby wounds—everything—would break apart, disintegrate; beauty would never be restored. The attempt would have failed.

Such painters will surely be criticized for their lack of tact: if they revisit these scabrous subjects, they should do so with both delicacy and caution. Tact was the outstanding feature of Titian's work, if I may be permitted to mention that great figure. Princes could commission a painting of a massacre committed to their orders and sleep soundly in their beds: he would turn it into a procession or a ballet. And it was beautiful, of course! If one paints tortures following his methods, they become tortures absent from the canvas, just as Mallarmé's poetic rose was the 'rose absent from all bouquets'. The torturers

will be shown in the richest fabrics, fine strapping *Reiter* overseeing the operation, with perhaps, at a pinch, the entrancingly beautiful, unharmed bare foot of a victim whose legs, trunk and head are hidden. On these grounds, I regard Tiziano Vecellio as a betrayer: he forced his brush to render tranquil horrors, painless pain and deathless dead: it is his fault that Beauty is a traitor to humanity and that it sides with kings. If a pig-headed painter with a room overlooking a triage camp paints fruit bowls, then that is not so serious: he sins by omission. The real crime is to paint the triage camp as though it were a fruit bowl.

I concede that there have been two exceptions. But the first is merely apparent: racked by remorse and revolt, the uncertain Goya, that tormented visionary, painted not war but his visions. He had no desire to enlighten the masses, being a man himself so unenlightened that the horrors of battles and executions gradually became, in the depths of his heart, the unvarnished horror of being Goya.

Guernica is different: here the artist most reliant upon chance took advantage of the most unprecedented good fortune. In fact, the painting combines some incompatible features. Effortlessly. The picture, an instance of unforgettable revolt, the commemoration of a massacre, seems, at the same time, to have striven only after Beauty; and indeed achieved it. The bitter accusation contained in the painting will remain, but that will not disturb its calm formal beauty. Conversely, the beauty does not

betray the accusation, but *helps to make it*. This is because the Spanish Civil War, a crucial moment in the pre-war years, broke out at a point when *this* painter's life and *this* style of painting were reaching their decisive moment. The negative force of Picasso's brush was exhausting the 'figurative' and clearing the way for its systematic destruction. In this period, figures were still intact, for the goal of experimentation was precisely to render the movement that brought about their disintegration. This violence did not need to hide or transform itself; it became merged, as violence, with the disintegration of human beings by their own bombs: thus an experimental method became the singular meaning of a revolt and the denunciation of a massacre. The same social forces had made a painter the negation of *their* order and had distantly prepared the ground for the fascist acts of destruction and *Guernica*. This stroke of fortune allowed the artist not to cajole the Beautiful. And if the crime, in entering the 'plastic arts', still remains an odious one, this is because it explodes, and because, to use a term coined by André Breton, Picasso's beauty is 'fixed-explosive' in nature. The miraculous throw of the dice couldn't occur again: when, after the 1939 war, the painter wanted to start over, his art had changed and the world had too; there was no meeting of the two. All in all, we are still in the same bind: when it is a matter of human beings and their suffering, we can neither accept the figurative representation of horror nor its disappearance beneath magnificent display.

For Lapoujade, the alternative no longer even exists; there no longer are any problems. I borrowed the foregoing examples from the figurative dimension. Paradoxically, if the human figure is imitated, the demand for justice comes from outside; if imitation no longer takes place, this demand comes from Art itself.

This is the most recent stage in a long journey. For years we have been discovering the nudes, couples and crowds that force themselves on his brush. Look at his adolescent girls: they lack nothing. Yet the flesh has now lost its surround: the imitated outlines of a body. Even so, it has not scattered to the four corners of the canvas. Outlines, volumes, masses, perspectival effects—there was actually no need for all this, then, to *put us in the presence* of a naked body? Obviously not. Or, rather, the opposite is the case: the picture requires *on its own account* that we sense the delicacy of a flesh tint at the very moment that it has been rid of alien forms.

The starting point is the restlessness of Art; the painter is freeing himself from an academic tradition: he wants to be able to cultivate his garden to the fullest extent, that plane surface that has come down to him. He wants to be able to transform the old routine farming of that surface into intensive cultivation. And then he will suppress the customs barriers and tolls, the roadblocks and detours imposed by imitation: this means both increasing the number of ways in which the work is determined and, at the same time, tightening its unity.

The deep motive for the experimentation lies in this: giving Beauty a tighter grain, a firmer, richer consistency. The artist's only concern should be art. And when we see Lapoujade's work, he doesn't seem to be looking for another way to paint but to be giving painting a new nature. The rest follows, of course. But the serious changes in all the arts are material first and the form comes last: it is the quintessence of matter. Lapoujade belongs to a generation of builders. After what he himself calls the 'disintegration of the figurative' by Picasso, Braque and a whole generation of analysts, all that was left for the newcomers was a teeming of colours and rhythms—shattered wreckage. They had no choice: these thinned-down, ductile materials permitted of, and were crying out for, integration into new wholes. Up to this point, these young people were a group and the same task awaited them all. Afterwards, each was alone: it was for each to question the new art as to its ends and resources. Lapoujade chose to restore the world to us. In my opinion, this was a decision of the first importance. But let us be assured that the world had asked nothing of art: if it made its return, bloody and new, that was because Painting demanded it.

Beauty is not a single-layered entity. It requires two unities, the one visible and the other secret. If a moment were to come, albeit at the end of a very long quest, when we summed up a work in a single view of it, the object would be reduced to its inert visibility, Beauty would vanish and ornament alone would remain. To put

it more precisely, the unification the brush constantly strives after, and our eye in its wake, must itself take as its goal the permanent reconstitution of a certain presence. And that presence, in turn, can yield its indecomposable unity to us only in the medium of Art, through the painter's effort—or our own—to construct or reconstruct the beauty of a whole. The act is purely aesthetic, but, to the very extent that no one concerns himself with it, the Whole insinuates itself into the visual syntheses, ordering and confirming them. In fact, the paths traced out by the painter for our eyes are paths that *we* must find and undertake to travel along: it is up to *us* to embrace these sudden expansions of colour, these condensings of matter; *we* must stir up echoes and rhythms. It is at this moment that Presence, that rejected intuition, comes to our aid: it does not itself determine the itinerary but overdetermines it. To *construct*, it will be enough to establish visible relationships. To safeguard that construction, to protect it from total absurdity, a transcendent unity is necessary. This unity ensures that the movement of the gaze will never stop: it is this constant roving of the eyes that produces the permanence of invisible unity. We shall, then, keep on moving around; if we were to stop, everything would break to pieces.

If you ask what this Presence is, I can reassure you right away: Lapoujade is no Platonist and neither am I. I don't think he is pursuing an Idea through his compositions. No, the regulative principle makes its appearance

in each canvas and remains inseparable from that canvas: neither can be said to exist elsewhere. This abstract painter wants a concrete presence in every picture. And if the same name has to be given to all these presences, let us say that each of his works has sought a meaning for itself and has, in each case, found one. But, above all, let us avoid confusion here: a meaning is not a sign or a symbol or even an image. When Canaletto paints Venice, the likeness is perfect: as half-sign and half-image, the Queen of the Seas has taken care to avoid any confusion: you can't mistake it. Hence the painting has no meaning. No more than does an identity card. When Guardi paints rags and the weathering of bricks by the most corrosive of lights, the chosen alleyways or canals are not, as they say, very meaningful. It's a stretch of wharf of a kind you find everywhere or a studied deformation of light. Canaletto uses his brush in the service of his native city; Guardi is concerned only with plastic problems, with light and matter, with colours and light, with achieving the unity of the multiple by means of a rigorous imprecision. As a result, Venice is present in each of his paintings; present as it was for him and as it is for us; and also as everyone *feels* it but as no one has seen it. One day, I visited a writer in the fine garret of a brick *palazzio* beside a *rio*. None of the forms that Guardi loves to paint was to be seen. Yet as soon as I saw the place, as soon as I glimpsed the condition of my host, I thought of the painter: I rediscovered Venice, my Venice, all of our Venices, and I have experienced the

same feeling about other people, other objects and other places. The same? Well, not quite: meaning depends on the matter in which it surfaces; Guardi will always say more than we feel, and say it differently. The fact remains that 'figurative' painting was the first to submit itself to the double unity rule. But, paradoxically, the incarnation of the invisible presence is more or less concealed in that form of painting by a brutal, mechanical bond which subordinates the portrait to its model in a manner external to the work of art. When an artist paints grapes, the belief is that the bunch of grapes is *incarnated* in his work. As though, ever since Apelles, the artist's only ambition were to deceive birds. Yet when Van Gogh painted a field, he didn't claim to transfer it to his canvas: he was attempting, by way of a deceptive figuration and with no other concern than for art, to embody in the application of paint to a vertical surface an immense, full world in which there were fields and people, Van Gogh among them. Our world.

Let us note that Van Gogh never tried to make us see a field with crows nor, even less, fruit trees, for the simple reason that these objects are not even representable. They provide an aesthetic material for the incarnation of that presence that defies the brush: the world covering itself with fields, the world spurting forth, all sap and flowers, from a magic wand. And the image still has to be very far removed from the model or else the world will not be 'captured' in it. It was essential that Van Gogh should begin by distorting everything, if

he wanted to show us through art that the most tender, most innocent of natural gracilities is inseparable from horror. There are, then, three elements in 'the figurative': a guide-reality, which the canvas claims to confront; the representation made of this by the painter; and the presence that eventually descends into the composition. One can understand that this trinity might have seemed awkward. It is. The guide-reality, ambiguous in its essence, guides nothing at all: it floats, belly up, and nothing will be done for it, nothing can be made of it unless it is rendered entirely real or, in other words, made into an imaginary object. No field will impart the charm or horror of the world unless it is seriously reconstructed; or, rather, it will impart both: together and separately. It will reflect everything, but incoherently: there will be no sureness of touch, but merely approximations, a hotchpotch, confusion. This dreary disorder will not, without some forcing, render the complex structures of the *felt* universe: what the painter will add to the canvas will be the days of his life, passing time and the time that does not pass. These powerful reagents will transform the represented object: it will not be the inert particularity of the model that passes into the picture but nor will the form traced take on the generality of the type or sign. The world's action on a human being and the human being's long passion for the world, both summed up in the mendacious flash of a snapshot, will endow these few acres of clay with a biographical singularity. It will fall to them to evoke the adventure of living, of contem- plating the very outbreak

of madness, of hurtling towards death. At the same time, this chance form, integrated, for want of anything better, into a composition, will undergo art's planings and filings, its removal of rough edges. Vincent says he 'is doing' a field, but isn't under any illusions: he creates order on a canvas without ever entirely wishing to restore to it the gentle yielding of the corn to the wind, nor entirely to call on to his canvas that enormous, intimate presence that is man, heart of the world, embraced by the world, heart of man. When at last he puts down his palette, when the presence is embodied in the composition, what has become of the representation of the object? It is a transparency, a memory, barely more than a magnificent allusion to the object represented. And the field, finally, the simple field the artist was trying to represent, would be eliminated from the canvas if the world did not come to its aid and incarnate itself, as unfigured swaying corn and harvests, in this thick paste of a rimless sun or in this wheel of suns at ground level that are the picture's only real inhabitants and the only true vestiges of the creative act.

In figurative painting, conventions have scarcely any importance: it is enough simply to convince us that the figure proposed is, within *this* reference system, the best representation of the object. The best: that is to say, the strongest, densest, most meaningful. It is a matter of skill or good fortune. However, since the last century, with every new option, the gap has widened between figure and represented object. The greater the distance

separating the two, the stronger the internal tension of the work. At the point when resemblance is thrown overboard entirely, when notice is given that all similarity between image and object is purely fortuitous, then meaning, liberated by the collapse of *representation*, manifests itself in its negative aspect. Meaning is the mark of this failure of representation and shines out through the dissemblances, lacunae, approximations and intentional indeterminacies. Though itself invisible, it has a blinding effect because it dissolves figures into its non-figurable presence. Such are the meanings that haunt our world too: they both obliterate detail and feed on it. Every brick wall, if it stands alone, hides Venice from me; I shall sense the city through the necessary disappearance of its palaces, the gathering of its plumage into a single feather that I do not see. On the canvas, the artist still offers us the figurative elements of an intuition but he strikes them out immediately: roused to life by this rejection, the Presence—which is the thing itself without details in a space without parts[2]—will take on body. But this is a trap set by the artist: he introduces other figures, whose nature is alien to that of the object designated, other material—paper, sand, pebbles—and other allusions; he wishes to produce a new entity: a presence all

2 This would seem to be a (contradicting) echo of Locke's observation that 'the mind is not able to frame the idea of any space without parts.' See John Locke, *An Essay Concerning Human Understanding* (Roger Woolhouse ed., introd. and annot.) (London: Penguin, 1997 [1689]). [Trans.]

the more austere for still being fuelled by an absence, but an absence already secretly falsified by substitutions. How many painters between the wars dreamed—as simultaneous chemists and alchemists—both of forcing gold into being and of imparting to it the character of base metal? One of them wished for a double transmutation; he wanted to paint a wardrobe that would be a frog without ceasing to be a wardrobe: a chosen signal would have made it possible—this was his hope—to take each of these objects as, in turn, plastic substance or incarnation. The aim was a suspect one: the intention was not to flush out the scattered meanings of the world and have us experience them, but to create others that had never existed. These were insignificant tricks, uninspired sleights of hand. At the end of this long crisis, in which artistic creation sank into illusionism because it had failed to understand that the imaginary is the only absolute, figuration had the good sense to explode. And meaning? Did that also disappear at the same time? Quite the reverse: as we have seen, there was no true connection between the two. Once released, the incarnate presence revealed itself as the most rigorous exigency of abstract art.

Images that break and fall to pieces are not a studied option on the part of the new painters but an event in progress, the consequences of which are not all known. This permanent deflagration is a chain reaction from one canvas to another: painters see it as both their problem and their material. Art gives them an explosion to

govern. They will do so by an explosive order. Their elders sowed the wind; those who wish today to master the whirlwind will have to become cyclones within the cyclone and organize the tiniest straw in that wind with implacable rigour. This pulverulence has to be preserved and reduced by invented laws and by a visual logic. They have to seek out the manifold unity of multiplicity and acquire a new sense of the canvas. They have to know how to give full value there to these dilations and thickenings, these revolving fields of flame, these black flecks, these spots, pools and smears of blood in the sun—and also how to contain them. They have to know how to employ these fluidities and densities as part of the overall ceremony of the artwork, using the most rigorous process of selection and pruning. There is no more hiding, no more fakery and no details are negligible any longer; there is simply a superabundance in which everything is of equal value. But, though he confines himself to experimenting with colours, to strengthening lines, to discovering opportunities and exploiting them, to structuring the whirlwind and, lastly, to counterbalancing local turbulences by pursuing a rigorous equilibrium, the painter will give definitive form to a tremendous event: at worst, we shall see a rose-window, at best a graceful merry-go-round.

To maintain the rhythm of the explosive space, to prolong the vibration of colours, to exploit to the full the strange and terrifying disintegration of being and its whirlwind movement, it is essential that the brush

impose a meaning on it and impose that meaning on us. No mobility without a path and no path without a direction—who will decide these vectoral determinations if the artist does not de-condition sight? But a very powerful motive has to be found for the eye to undertake the unification of this sumptuous dispersion, without seeking a figure or a likeness in it. Only one such motive exists: the secret unity of the work.

This is, so to speak, in the picture itself. There is, said Éluard, another world and it is in this one. But we shall not find this unity if we do not ourselves proceed to unify the canvas. Each time we effect new syntheses or the eye establishes local unities, the presence is revealed a little more. We shall never have the whole of it, for it consists only in the work itself, regarded as an organism. Lapoujade was invited by Art to reject the false unity of the figurative. Barely had he done so when he understood what was being asked of him: chance must be driven out and this indefinitely divisible surface must be endowed with the indivisible unity of a Whole.

Some have felt as he did on this. They have chosen lyrical unity. The painter hurls himself into his canvas with all his *élan*, only then to resurface from it and hurl himself at us. He has painted the way one strikes a blow: the presence embodied in the work is his own. He gives his work the lithe unity of an assault. Lapoujade doesn't think lyrical painting wholly impossible. It is feasible; it has been done. Done already. For his part, he would be

afraid that this self-projection into the pure medium of art may not be readable. And, of course, despite what is too often said of it, Art is not a language. But it isn't true either that we communicate only by signs. We *experience* through others what others *experience* as we do; we are, for our fellow creatures, a shared source of experience. And these painters aspire precisely to impart the unity of their emotions—an impulse or a release—to the canvas; in short, they choose the exhibition-going public as the people to whom to impart the experience of their own particular adventure. Is this possible without some prior unanimity? Singularity can be discovered only as a differentiation from what is common to all. If it were just a matter of painting, everyone could take their chance: art would remain intact, even if it locked itself up in hermeticism. But lyrical painting presents itself also as an act that sets its indispensable seal on multiplicity. Art demands that I repeat that act; Beauty doesn't occur unless I have repeated it.

Since the eye's immediate motive is communication and since communication represents both the completion, endlessly recommenced, and the perpetual animation of the abstract work, the painter must have a direct, constant concern for it. Since meaning is revealed through unification, and since it becomes unified in revelation, it must by nature be communicable. To set conditions without giving oneself the means to fulfil them is to run the risk of ultimate failure, of the work sinking into indeterminacy.

This, I believe, is Lapoujade's deepest conviction: painting is a great avenue of communication; at every crossroads it finds the presences it embodies. And yet it doesn't have to go looking for them. If the artist wishes to gather meanings, they are to be had by the dozen; the eye will perhaps read them, but languidly, without becoming spellbound by their obviousness or their necessity. If they are not both necessitated by the tremors of a material in process of organization and by urgent imperatives shared by painter and viewers, how could they be imposed upon us? These obvious facts meet; the artist is there and we all come together. If he hears the confused murmurings of the highways and byways, without even straining his ear to catch them, this is because he is himself a crossroads, as we all are. Yet there are still some deserted or disused avenues here and there. Lapoujade, that infinitely diverse crossroads of man and world, is a traffic jam, a marking-of-time suddenly interrupted by shouts or silence, who stubbornly restarts after mysterious asphalt-hued moments of suspense. He believes solitude doesn't suit painting and his canvases have convinced me of it.

One day, said Marx, there will not be any painters: just human beings who paint. We are a long way from that. But Lapoujade is this strange contradiction: with a number of other artists of the same age, he is the man who has reduced painting to the sumptuous austerity of its essence. Yet, amidst the human presences embodied in his canvases, he is the first not to claim any privilege.

As a painter, through his painting, he tears off the artist's mask; there remain only human beings and this one, with no special prerogatives, a man among other men, the painter abnegating himself by the splendour of his work. Look: he has painted crowds. He is not the first to do so: with people on canvases it was always 'the more the merrier'. But the old masters kept themselves safely tucked away: they worked at the prince's right hand and on a dais. Or, at a pinch, facing the populace and on a level with it, but protected by soldiers. There was no mistaking what the work was meant to say: 'I'm a painter, I belong to you, the rich and powerful; I'm showing you—from the outside—the rabble you govern, from which your favour has removed me for all time.' The age was responsible, but 'figurative painting' was too. How was one to paint the crowd as seen by itself, as it experienced and made itself, here and everywhere; what curve could one impart to space to inscribe in it that infinite circle whose centre is everywhere, merging everywhere with its circumference? How could each individual be depicted as both driver and driven? And what shapes, what colours would show that each of these human molecules is incomparable to the others and that all are interchangeable? What system of reference could one choose to make art-lovers understand that a crowd receives a painter into itself only by undoing him; that he finds he is not allowed the minuscule distance, the tiny independence of eye that makes for reliable

testimony; that the alerted masses refuse to open themselves up to witnesses and that you have to go in there entirely naked, without any special badges of honour, simply as a man. You have to take part in everything, to flee or to charge, to become a driven driver, to be both active and passive. You have to bear the weight of twenty or a hundred thousand other 'selves' to be able to come back to one's painting with, in the best of cases, a memory that is violent but formless. The internal reactions of a mass gathering are not visible to the eye: they invade you, you experience them and, in the end, you notice you are having those reactions. Just try and depict that figuratively!

Here, then, is the new painter of crowds: he can embody their presence only by refusing to represent them. Of course, when he drives the Figure from his studio, he, like all artists, pronounces that vow of poverty that Beauty has always demanded and always will. But he does much more: he spurns the dais; as a man, he refuses to be excluded by the privileges of his mission and to contemplate his species from outside. The figurative is a double exile, the rejection of the painter by the model and vice versa. By deforming the figure, anarchistic bourgeois artists spoke to us with gentle irony of their solitude: you see, there is no communication!

On the other hand, if one is Lapoujade, communicating is what one does first. One is a real, stormy, troubled crowd; one *exposes oneself to it* and, after the

progressive elimination of the detail, there remains the *meaning* of the demonstrations at the Place de la République, of the police charging on 27 October.[3] The meaning: an experience had by thousands of strangers, certain that it was the same for each of them. To embody that experience, a material is required: language is not enough; it breaks down a multiplicity of facts, each of which derived its meaning from the others. Provided that he, as a painter, attempts to set down only his diverse, multifarious adventure as an interchangeable human being, Lapoujade will lend his crowds a material form that is shifting but rigorously unified within dispersion. The unification of the atomized particles brings something beyond them into being: the explosive unity of the masses. On the basis of which, the crowd is, in each individual, called upon to recover the detailed totality of a life. The painter guides us: there are, he says, immediate data of expression:[4] the sombre, dense heaping-up of colours in the lower part of the canvas, a raising of matter, the joyful upward spurting of light, a hundred

3 Presumably a reference to the demonstrations of 27 October 1960, which was a national day of action for Algeria called by the major trade unions. [Trans.]

4 *Les données immédiates de l'expression*: the phrase echoes Bergson's 'Les données immédiates de la conscience' (The Immediate Data of Consciousness). See Henri Bergson, *Essai sur les données immédiates de la conscience* (Paris: F. Alcan, 1889); reprinted in Henri Bergson, *Œuvres complètes*, VOL. 1 (Geneva, Skira, 1945–46); *Time and Free Will: An Essay on the Immediate Data of Consciousness* (F. L. Pogson trans.) (London: George Allen and Unwin, 1910). [Trans.]

others, a thousand others: they are the key elements of the *dispositif.* But their appeal is solely to the heart. The singularity of the paths traced by the brush is what is essential. Compact in places, rarefied in others, laid on thick at times and liquid at others, the matter of the painting doesn't claim to make the invisible visible, to achieve that metamorphosis around us, and through us, of a clearing in the scrubland, the steppes or the virgin forest. By its texture and its itineraries, it merely *suggests*. The contrast between the rigorous determination of the artwork and the relative indeterminacy of the experience or ordeal, serves the painter; the tight patches of paint seem to move apart from each other; a new path, suddenly uncovered, forces the colours to pale by establishing new relations between them: we shall, in the end, through these metamorphoses, grasp the presence 'without parts' of the demonstration as it is embodied with all its densities at once. And then, suddenly, there is a streak of asphalt: the void. This overflows and runs off to the bottom of the canvas. But is there a top or a bottom? The space is itself *a meaning*; it is composed by the crowd and is determined as a function of the crowd's acts. This streak is, simultaneously, a thick downward plunge and a flight to the horizon; it matters little which. It is the sudden opening-up of the void: the police are charging. Are we going to run or resist? Whatever we do, the space exists with all its dimensions in one: it is distance—which shrinks on one side and, on the other,

seems interminable. But what good are words, the patch of paint is enough: the meaning is resuscitated. Not, as in the age of the conjurors, a faked-up presence, such as a fish/wardrobe or a wolf/table: the real presence, but indecomposable—that is to say, both general and particular, enriched for everyone by everything he has succeeded in putting into it, by everything the man who paints has put into it.

Man amid men, men amid the world, the world amid men: this is the unique presence claimed by this unmastered explosion; this is the single—particular and general—test that Lapoujade undergoes with us, by us and for us; the single communication that we are a part of from the outset and that illuminates the canvas even before being illuminated by it. But this rejection of privilege, identical to the rejection of figuration, is a commitment by the painter and the man: it leads Lapoujade, as he passes from one painting to another, towards the most radical consequences of the undertaking. And, first, if the painter is no longer a contemplative being, if he is thrown out into the midst of all his peers—other human beings—the constant bond that unites him with, or sets him against, each and every one is *practice*. He acts, suffers, frees himself and dominates or is dominated; contemplation was merely passive; the brush must render action: not from the outside but as the ordeal of the Other suffered by the man who paints him: the Meaning will be the incarnation of the Other, as known from the

change he is made to undergo, and of the painter himself discovering himself through that change which *he* undergoes or inflicts. However it is painted, the inertia of a Nude is generally distressing: the woman is alone, with the painter at the other end of the room. No one in real life—and particularly not the painter—has contemplated such a docile Nudity from such a distance. Lapoujade paints couples. He has, at times, evoked the tenderness of adolescent flesh. But in the erotic series he entitled *le Vif du Sujet,* he has tried to suggest woman as men approach her, as she appears in the act of love. A Nude, when all is said and done, is something in which two people are involved. Even if the only presence is female, the male is suggested in the very movement of the colours; that is what gives *this particular* presence to the female inhabitant of the paintings. By becoming the totalizing unity of the bursts of colour and matter, action, the many-sided relation between human beings, brings an ultimate precision to the painter's project: the non- figurative offers its visible splendours to the incarnation of the non-figurable. The abstract order initially seemed limiting; in fact, it reveals a new field and novel functions for painting.

The other consequence of this option is clearly the decision the unprivileged painter makes to mark his solidarity with other human beings. This solidarity is something self-evident: he has only what they have; wants nothing more than they do; is nothing more than they

are. And then, this is a kind of permanent act: woman appears on his canvases through love, men through the common struggle. The most surprising but simplest truth is that the choice of abstraction should, in the very name of art, reinstall man on Lapoujade's canvases. Not, as he was for centuries, in the guise of prince or prelate, but modestly, anonymously, in his patient, stubborn struggle to escape hunger, to free himself from oppression. Man is everywhere in Lapoujade's paintings: he has, in fact, never stopped painting human beings or deepening his depiction of them. At the present moment, he understands that Man, seen by an unprivileged eye, is primarily neither great nor small today, neither beautiful nor ugly: art commands him to set the human realm on his canvases in all its truth. And the truth of that realm today is that the human race comprises torturers and their accomplices, and martyrs. The torturers are few in number, the accomplices far more numerous; the majority is made up of torture victims or candidates for torture. Lapoujade has understood this: no one can speak of men in 1961 without dealing first with persecutors; no one can speak to the French of the French unless he first speaks of tortured Algerians: this is the face we show to the world today; let us contemplate it as it is; afterwards we shall decide whether to retain it or operate on it.

Lapoujade chooses to show torture because it is our deeply ingrained truth—alas, our ignoble truth. At the point when he attempts to paint it, he notices that his art, which called forth the unity of this 'meaning', was

the only art that permitted such a depiction. The trip-
tych is beautiful without reserve; it may be so without
remorse. This is because, in non-figurative painting,
Beauty does not conceal, but *shows*. The picture will not
present anything to be *seen*. It will allow the horror to
descend into it, but *only if it is beautiful.* By this I mean,
if it is organized in the richest, most complex way. The
precision of the scenes evoked depends on the precision
of the brushwork; in the tight drawing and grouping of
this concert of striations, of these beautiful but sinister
colours, lies the only way of making us feel the meaning
of their agony for Alleg and Djamila.[5] But, though it
enhances the plastic vision, meaning does not, as I have
said, bring in new elements that are foreign to the
ensemble as seen. Meaning will embody itself: in this
frenzy of colours, we shall apprehend bruised flesh and
unbearable suffering. But that suffering is the suffering
of the victims. Let us not claim it is—in this discrete,
imperious form—unbearable to look at. Nothing
appears other than (behind a radiant Beauty, and thanks
to it) a pitiless Destiny, which human beings—which
we—have made for humanity. The success is total; this

5 Henri Alleg and Djamila Bouhired, two of the most prominent
victims of torture in the Algerian national liberation struggle. Alleg
published the memoir, *La Question* [Paris: Editions de Minuit; *The
Question* (John Calder trans.), London; John Calder Publishers Ltd,
1958] in 1958. Both the book and an article which Sartre wrote
about it in *L'Express* (March 1958) were subjected to various forms
of censorship by the French government, including an official ban-
ning order which appears to have been relatively ineffective. [Trans.]

is because it originates in painting and its new laws: it conforms to the logic of the abstract. It is, I believe, quite a noteworthy event that a painter has been able to give such visual pleasure by showing us, unvarnished, the shattering bereavement of our consciences.

Méditations, 2 (second quarter 1961).
On an exhibition by Lapoujade
entitled *Foules* (Crowds)[6]

6 The exhibition in question at the Galérie Pierre Domec, 10 March–15 April 1961, seems in fact to have been entitled *Peintures sur le thème des Emeutes, Tryptique sur 1a torture, Hiroshima* (Paintings on the Theme of the Riots, Tryptich on Torture, Hiroshima). [Trans.]

<div align="center">

✳

</div>

<div align="center">

MASSON[1]

</div>

The artist is a suspect; anyone can question him, arrest him and drag him before the judges; all his words and works can be used against him. He has some major advantages, but, in exchange, every citizen has the right to call him to account. If Masson painted his children, he would be asked whether he loved them. And why paint his children rather than a potter, a fuller or a Gaulish warrior wounded at Vercingetorix's side? He prefers to draw Titans and hence he will be asked the preliminary question: do you believe in your mythology? If he were not sincere, he would lose any chance of making

1 André Masson (1896–1987): one of France's leading Surrealist painters before breaking with André Breton in 1929 and pursuing a more structured style. During the war years, he escaped to the USA where he developed a strong interest in African-American and Native American mythological themes. He was close to many writers, collaborating on the review Acéphale with Georges Bataille (his brother-in-law), Roger Caillois and Pierre Klossowski. In 1946, he designed the sets for the first production at the Théâtre Antoine of Sartre's play La Putain respectueuse [The Respectful Prostitute] (Paris: Nagel, 1946). [Trans.]

an emotional impact. Of course, we don't require a contemporary French painter to have the faith of Hector Hippolyte, the Vodou priest who painted Goddess Erzulie and Baron Samedi as he saw them every day. But there are many different ways of believing. If these monsters had come from his pen of their own accord and his own will had played no part in them, if he had remained the mere witness of this automatic drawing and seen it as expressing his hidden desires and unconscious terrors, I would say he believes in them. But this is not the case: if he acknowledges that 'some subjects appeared unexpectedly', he adds afterwards that they 'came in by accident, swelling the initial river'. What is more, he is not the witness to his work: he has no need to learn its meaning, since he knows the meaning as he makes the work: 'There isn't one of these drawings in which I can't explain the symbolism. It would even be easy, with most of them, to make out an origin . . . [they are], in short, the products of my culture and my dealings with the world . . . Moreover, reminiscences of things seen.' There is nothing here that presses itself upon him in the manner of an obsession: Nature and other people have supplied him with pretexts. But perhaps what is at issue here is a conventional language he has deliberately adopted, which he regards as alone capable of symbolizing the world of eros: wouldn't that be another way of believing? No; what do they symbolize, these bleeding eagles wresting themselves from the earth? The difficult break with the past and with custom, with instincts and our animal

natures, with traditions and conformism? The painful, abstract solitude of pride? Transcendence? The trauma of birth? 'The horror of the earth in which its plumage is caught' (Mallarmé)?[2] Everything and nothing, anything you like. On the contrary, these giants came to him from a friendly conversation on Bachofen. Since Masson knows this, he is no longer an adherent of symbolism; he is clothing a body of knowledge. He is doing what he likes doing: the pencil launches out, sketches the curves that come easiest; the form emerges, unfinished and ambiguous. In a single movement, Masson deciphers that form and traces it out; he invents the interpretation from the figure and subjects the figure to the interpretation. In a sense, he believes so little in what he is doing that this little piece of pyrotechnics is a farewell. Masson has made these drawings in order to take his leave of all mythology.

Should we condemn him for this? Should we see this imagery merely as a literary conceit? Far from it. It is by taking his images seriously that he can be said to be making literature. Since reality can be approached without the aid of metaphors, why, then, disguise it in a tawdry get-up? It isn't a painter's business to invent symbols for the libido or the Oedipus complex: mental patients take care of this and will do a much better job of it. Masson's bestiary is born of a more profound, more

2 From Stéphane Mallarmé, 'Le vierge, le vivace et le bel aujourd'hui', in *Œuvres Complètes I*. [Trans.]

technical concern. It is a provisional response to the question his painting raises for the painter. Are we saying, then, that a mythology can resolve a problem of technique? Yes, if the technique and its problems are themselves born of a myth. Masson is mythological in his essence—every bit as much as Bosch or Hippolyte. But his myths lie well this side of sexuality, at the level where, to speak like sociologists, 'nature' and 'culture' are indistinguishable, where one cannot separate the project of painting from the project of being a man.

Depending on their temperaments, poets and artists employ two main types of inspiration, the one expansive, the other retractile. There is avarice and fear in this latter: one gathers together, delimits, stifles, confines and corsets within outlines; one does what one can to persuade oneself and others that things are absolutes, that space is a shadow, a conceptual order and that plurality is merely an appearance donned by unity. One autumn day, Coppée accompanied Mallarmé on his daily walk. The following year, Mallarmé wrote to him: 'My walk reminds me by its autumn . . .' There is a large degree of avarice in this: all walks heaped into a single one. I see Mallarmé's walk—he had his wife, his daughter, his cane and his walk—as a revolving ball: the seasons, days and hours are lights that tint it delicately. This Platonism is a myth. And the outline is an analogous myth in painting: you won't find 'in Nature' those window-leadings that frame Rouault's faces; they express nothing visible but, rather, a holy terror, the hatred of change and plurality, a deep

love of order, which aims, beyond the lacerations of time and space, to restore their calm everlastingness to objects. Rouault paints the world as God made it, not as we see it, while Cézanne paints Nature 'as God lays it out before our eyes' and Gris paints 'that initial idea, that notion of the object which is equal for all and which, in our example of the table, is shared by the housewife, the carpenter and the poet.' If the notion is shared by all, it belongs to no one as his own: Gris' table is the table seen by an abstract, universal subject.

We may contrast Rimbaud: 'Dawn, like a flight of doves' or 'its scarlet and black wounds shine forth from glorious flesh. The true colours of life deepen, dance and detach themselves around the Vision in the making.'[3] This is what I shall term the unity of fragmentation. Far from the plurality of substances being concealed, it is emphasized; even where it is not visible, there is an assumption of diversity, but that diversity is then made to represent the unity of an explosive power. The poet who sees the dawn as a flock of doves explodes the morning like a powder keg and says: this deflagration is the morning. For thinkers of this particular bent, beauty becomes 'fixed-explosive'.[4] The impenetrability and corpse-like rigidity of space will, by the poet's artifices,

3 From Arthur Rimbaud, 'Being Beauteous', in *Illuminations* (Louis Varèse trans.) (New York: New Directions, 1957).

4 French: 'explosante-fixe'. André Breton, *L'Amour fou* (Paris: Gallimard, 1937) [*Mad Love* (Mary Ann Caws trans.) (Lincoln: University of Nebraska Press, 1937)]. Breton contrasts this type of beauty with two others: the 'veiled-erotic' and the 'circumstantial-magical'.

become a conquering force, its divisibility to infinity a glorious efflorescence. Every object extends everywhere, through everything. To be is to quiver in an infinite agonizing struggle and to be a part, while clinging on to oneself, of the furious terrestrial tide which at every moment claims new regions of being from the nothingness. This dionysian myth causes us to swell pleasantly and fills us with a sense of our power; in the poet it draws its source from an infernal pride that agrees to die in order to be everything, from a self-assured generosity both giving and losing itself. A creator's myth: one thinks of the Jesus Patibilis of the Manichees, crucified on matter and making the entire world 'the Cross of Light'. But for those who want to change the world and reinvent love, Jesus simply gets in the way. Or, rather, the Saviour who, in all things, shows his 'pathos-laden face' is man himself; their aim is to pin the exteriority of Nature down to reflecting human transcendence back to man.

These are myths, then, and myths, also, the fragmentation wrought by Impressionism, its exploding of forms and negation of outlines. And the dynamism of Masson is a myth too. The painting of Cézanne, Rouault and Gris reveals their belief, admitted or otherwise, in a divine almighty power; Masson's is characterized by what Kahnweiler terms 'the intrusion of the existential element'.

But do not look for anguish in it—at least not first and foremost. No; but while the painters of forms seek to paint Nature without human beings and still believe

the experimenter can withdraw from the experiment to contemplate it from without, Masson knows the experimenter is an integral part of the experimental system, that he is a real factor in the physical event and that he modifies what he sees—not in his mind, as idealists contend, but out there in the world—by the mere fact of seeing. This artist wants to put the painter in the painting and show us the world with man in it. The temptation will be to call him a painter of movement, but that isn't quite exact. He is trying not so much to represent a real movement on a still canvas as to reveal the potential motion of stillness. He has not, for many a long year, thought of eliminating outlines, so powerful is the influence of Cézanne and Cubism on the painters of his generation; but he struggles immediately to transform their meaning. At the same time as he is attempting to pin down this perpetual upheaval, these serial protoplasmic explosions that seem to him to form the innermost contexture of things—their substance—he is trying to metamorphose the line that surrounds them into an itinerary, trying to make it the arrow which, on a map, indicates the movement of an army, a mission or the winds. But whose itinerary? The movement of whom or of what? This is where Masson's original myth is to be discovered, his myth of the human being and of the painter.

Imagine a line drawn on a blackboard: all its points exist simultaneously; this means, among other things, that I am free to travel along the series in any direction.

And no doubt I have to 'pull' this line and my eyes have to 'follow' it from one end of the blackboard to the other. But, as they move from right to left or from bottom to top, I still have in my mind—and even in my eye muscles—the felt possibility of moving them from top to bottom or from left to right, so that the movement they carry out seems to me to be the pure effect of my whim and has nothing to do with the figure under consideration: the line is inert. However, in certain cases and for certain reasons, it may be that my eyes are compelled to obey a definite itinerary in following this line: it then becomes a vector. In that case, my gaze slides from one point to another like a glass alley on an inclined plane and its motion is accompanied by a sense that no other motion is possible. But since I can no more travel backwards along this line than one can travel backwards in time, this impossibility confers on space, in one specific region, the irreversibility that properly belongs only to time: I project the movement of my eyes into the line at the same time as I carry it out. It seems to me that the movement comes from the line, and I make this slipstream of light one of its properties. The line both exists already and forces me to trace it out. Succession is, in this way, embodied in juxtaposition; space absorbs time, becomes imbued with it and reflects it to me. And since causality is merely the unity of the moments of an irreversible series, the line ceases to be inert and manifests a kind of inner causality. Each point on the line seems to me the effect of the points I have passed through to

arrive at it and the cause of the points I shall pass through thereafter. Being pushed out from the preceding segment, it seems to project the following segment out in front of itself, when in reality it merely projects my gaze forward. The mind strings the points together into a synthetic unity of apperception, at the same time as, in each of them, causality plays the role of a disintegrative power; in this way, the vector appears both as substance and event; it seems to be its own cause since it both *is* already and creates itself through our vision.

But let us come back to painting: if the outline of painted objects is merely a line, everything sinks into the eternity that is a timeless inertia; but if the painter can turn the outlines into vectors, then the viewers' eyes could be said to confer on them the living unity of a chain of melody. This is Masson's dream: that his painting should be more urgent, more insistent than that of the Cubists or the Fauves, that it should contain an additional exigency. This is his ideal: that everything should organize and create itself before your eyes if you read it the right way round; that everything should scatter into chaos if you read it against the grain. And this is his problem: how to compel us to grasp the lines in his pictures, and particularly the outlines of objects, as vectors. In other words, what are the psychological factors that can prevail on us to see a mountain or a road going in one particular direction?

The answer is clear: a line becomes vectorial only when it reflects back to me my own power to move my

eyes along it. It seems at each point both to retain its past and to outrun itself towards its future but in fact it is *I* who outrun myself; the orientation of the vector is merely the provisional definition of my immediate future. But as the line is, in itself, a mere juxtaposition of points, the demand it exerts is not the product of its physical structure but of its human signification. I can see the road that runs beneath my window as a strip or as a flow. In the former case, I view it in its material aspect; in the latter I consider it in the totality of its meaning, like the wake left behind by marching crowds, or a static vehicle that will shortly carry me to my place of work; I incorporate into this whitish strip the oriented labour of the road-builders who made it or the road-menders who maintain it, the quickening force of the lorries that run along it, the call of the great factories of eastern France that it 'serves'. Its vectorial nature is, if you will, 'frozen human labour'. But, you may say, a mountain is not something made by man and yet I can choose to see it as something rising up or as a mass of fallen earth. Yes, but that depends on whether some precise motive compels me to 'read' it from base to summit and find in it the movement of an arrogant ascent, or from summit to base, when it reflects the image of the social forces crushing me and my secret prostration. In a word, the line or surface will force themselves upon me as vectors only if they manage, by some particular means, to reflect human transcendence. Every vector is already a myth because it secretly appeals to anthropomorphism: it is a sacred space.

If the painter wants to breathe life into his picture, let him project human transcendence on to things, let him unify them—even more than by colour harmonies or formal relations—by sweeping them all up together in a single human movement; let them form the act of taking, rejecting, fleeing—in a word, let man, visible or hidden, be the magnetic pole that draws the whole canvas towards himself. This is Masson's intention; but in him, ends and means are mingled: if the human dimension haunts his paintings and engravings, that is because he sees Nature through man; the thunderbolts that streak across his paintings express the initial choice this Dionysian artist made of himself, his refusal to wrest himself from the world to see it from some Olympian height, his desire to plunge into the heart of being and to paint the tracks left by his descent into the world. Man is the refractive medium through which Masson sees things and wants to make us see them, the deforming mirror that reflects faces back to him. For in Masson's work, man himself is seen through man. If a painter of the last century wanted to represent some horrible character, he would give him the forms and colours he thought likely to inspire horror in us: Masson wants to imbue his monsters with the horror they inspire, not offer them with all the deformations our horrified gaze produces in them. Where Titian or Rubens painted a woman as desirable, he wants to paint her as desired. Man's desire slips into this female flesh, acts as a leaven on it, makes it 'rise', stretches it, shapes it; the outlines of a breast are traced

by a caressing hand; the entire body becomes a thunderbolt, the lightning flash of a ravishment, it bears the marks of the havoc wrought upon it. There are no circles any longer, but whirlings. No vertical lines, but ascents or falls or downpours. No light any more, but simply grains of energy. 'Cosmogonies, germinations, insect dances in the grassy jungle, eggs hatching, eyes bursting within the mother-earth, in the recesses of the female earth.'[5] The outlines must dance; there is only one goal to this immense witches' sabbath: to decompress the tightly knit grain of being and free its internal energies, to introduce succession into bodies. Masson wants to paint time.

How will he paint it? How, in fixing on the canvas these neutral, inert surfaces, which we can choose to regard as still or mobile, will he compel us never again to see them at rest? How will he force us to see them, once and for all—and even against our will—as these turgescences, these erections, these screes, these flows, these funnel-shaped whirls, moulding the substance of being? I saw this mountain as a great dormant heap. How will he transform it for me into this sharp ascending mass that suddenly breaks off, slants away and runs off towards the east? He is constantly searching for ways and means, for solutions. What if he abandoned the line? No, he won't give it up until he has worn it threadbare.

5 Georges Limbour, *André Masson et son univers* (Geneva: Editions des Trois Collines, 1937), p. 103.

Though a prisoner of the outline, which is a halting, a finitude, he wants his canvas to be one whole outburst, one whole blossoming; this fertile contradiction is at the origin of all his advances.

From this point of view, his mythologies are ultimately just one of the solutions he has tried, and perhaps the most naïve. One day he trapped the sun.[6] The mousetrap that captures the sun in its steel jaws has no other goal than to manifest that heavenly body's 'intensibility' and its 'coefficient of adversity': once caught, the planet turns into a mouse and this gentle round mass rolls in a rumpled ball along an iron bar. It has become prey; the giant instrument bears witness to the human presence even in intersidereal space; a proof of the existence of man, just as the ordered movements of the heavens were for so long a proof of the existence of God. A rather literary proof. Masson soon abandons this approach and moves on to riddle-drawings: since Man alone infuses Nature with spirit, it is the human form he is going to inscribe everywhere, the human form he will have shine out for a moment atop everything and break down into vegetal sprays and mineral splashes. The tree here is a hand:[7] don't try to work out what Masson means. That would be to descend into literature. Masson doesn't engage in literature; he means nothing but what

6 *Piège à soleil* [Sun Trap] (1938).

7 Limbour, *André Masson et son univers*, p. 38. See also *Deux Arbres* [Two Trees] (1943). [Trans.]

he says: the branches are fingers because only fingers spread apart, open up or clench, so as to take and grip; he asks of fingers only that they transform foliage into a gesture. If the shales here[8] evoke the image of a skeleton, this is because only man—and a few apes—stands upright: they represent a standing mountain. Look at this *Paysage de la Martinique* [Martinique landscape, 1941]: the hills are thighs, calves, sexual organs; the roots are hands, without ceasing to be roots; you can see this as a tangle of limbs or a panorama, as you please. But it would be futile—and dangerous—to see this as the indication of some pansexualism: we would be falling back into metaphor. Legs and calves here assume the function of those arrows that are drawn on battle-plans, on the plans of strategic operations: they transform the lines of the mountain tops, the outlines of the hillocks into vectors. The best thing would be for us to sense these half-hidden muscles that silently drive the whole painting forward without our eyes actually noticing them. As for the female sex organ, which we find in so many pictures, it evokes neither fecundity nor rutting for Masson—or, at least, not initially. It represents discord, the gaping void, the explosive dislocation of a body. As early as 1922, in his *Croquis de femme* [Sketch of a Woman], he gave the parted legs of his models the role of suggesting the action of two forces applied at the same point,

8 André Masson, 'A la cime de l'Être', in *Mythologies, Volume 3: Mythologie de l'Être* (1939) (Paris: Éditions de la revue Fontaine, 1946).

pulling in opposite directions. The sex was the bursting-out of the rent flesh as an effect of that tension; this is why Masson's pencil will so often transform it into a wound. We shall, at any rate, meet it again in most of his landscapes. Merely hinted at or highlighted, this tortured sex between parted legs is neither sign nor symbol but, rather, a motive schema. For, as Limbour has rightly underscored, it is discord that characterizes Masson's pictures. Not that Masson is particularly aggressive: but this balanced unbalancing will alone express that human transcendence he wishes to paint on to things, which is always both ahead of and behind itself, both particle and wave at the same time, still caught in the toils of being and yet already far off in the future, already laying siege to the places the bulk of the herd will come to occupy later. This discord blossoms into a mythology, for it imposes on Masson his forms and his subjects. Since we retain outlines and want to make the line signify the opposite of what it manifests ordinarily—not finitude but explosion, not the slumped inertia of being, which is what it is and nothing else, but a certain way of being all that one is not and never being quite what one is— we are led to make the line itself an ambiguous reality, like those double lines which, at places where a circle meets another, belong to the circumference of both and are, at one and the same time, themselves and other than themselves, themselves and their own wresting from themselves. Limbour has already pointed out how 'the main actor in the picture is a movement, clean lines

which, with a lively—even a rash—*élan,* catch in their loops and at their extremities on to a number of individual attributes in which we recognize animals: heads and mouths, crests, feathers, tufts of fur, claws, etc.'[9] But this cannot be enough for Masson: it is by no means sufficient that the line is an arrow flying from one point to another; it has also, at each of its points, to be a becoming, an intermediary between one state and another: if all its inertia is to be expelled, the outline must enwrap a metamorphosis that is occurring, and we must never know whether it ends as a man or a stone because, within its confines, the stone becomes a man. In Masson's works, things are thus doubly human: they change into human beings so that the brushstrokes portraying them may suggest both movements and qualitative alterations. Masson comes, in this way, to retrace a whole mythology of metamorphoses: he brings the mineral, plant and animal kingdoms into the human realm. And, still in the same spirit, to unite these ambivalent forms by intimate relationships that are, at the same time, repulsions and dissonances, he devises a way of counterpoising them in the indissoluble unity of hatred, eroticism and conflict. When he draws *Two Trees* in 1943, it is not enough for these trees to be half man and woman: they have to make love into the bargain. And in *The Rape* in 1939, the two characters fuse to each other in the gaping, pained unity of a single wound, a single sex.

9 Georges Limbour, 'Georges Braque à Varengeville', in *Dans le secret des ateliers* (Paris: L'élocoquent, 1986). [Trans.]

This is how his subjects—rapes, murders, single combats, disembowellings and manhunts—are born. But this monstrous universe is simply the complete representation of *our* universe. All this violence is there not to symbolize the savagery of our appetites and instincts: it is needed to fix our gentlest, most human acts on the canvas. It takes every bit of this frenzied eroticism to depict the most innocent of our desires. Sadism, masochism—all is in the service of movement. We have to see this fantastical, tortured fauna as the most ordinary of animals, plants and human beings. Masson believes in these nightmares, but they are the effects of his atheistic realism. Such are rocks, plants and man himself for man if God does not exist.

The drawings he offers us today make up his ultimate mythology. In them, a self-conscious art aims to express all the phases of movement. One should look to them for the graphic representation of movement and becoming. Not for anything else: that is certainly enough. Look at drawing no. 15, *Winged men caught in blocks of ice, breaking free from this Himalaya of polyhedrons only at the price of their skins*. First, what is it? A spurting forth: a sheaf of arrows, a divergent, ascending movement.

Why do these men have wings? Why are these winged creatures men? Because, without wings, the men would appear to be standing, not rising: the earth would be their support; they would, in the end, be obeying gravity and one might, with a certain malice, still see

them hunkering down, bearing weight on their own feet. But the wing crowns the movement and completes it: it is not dynamic in itself and acts only through its signification. Look closer at these wings: they are an encumbrance; they fall down and turn inside out like umbrellas in the wind; only the human body will be able to represent effort and breaking free. And why are these men headless? Because the head arrests movement or channels it, diverts it to its advantage; even when only roughed out, it assumes too much importance: the force will be the greater for being blind. These creatures are made to be seen, not to see; a single gaze and everything would congeal. And why the blood, why the polyhedral crystals? Blood, pain and clenching of the muscles represent resistance; they communicate a grasping power to the pure matter: even the inert is a clutch, a claw. But, on the other hand, these claws have to be inert; the contrast between mineral and muscle has to be pushed to extremes; and what better symbol of the unalloyed, sombre obstinacy of the mineral than these polyhedra of ice? Wings, blood, crystals—here we have imagery in the service of movement: the human body, by contrast, provides the direct representation of soaring flight.

The eye is everywhere tugged apart by contradictions to the point where it explodes: the adolescent here is bowed down, like Atlas, beneath the weight of the world; he is leaning over to pick a flower. Is he leaning over, is he bowed down? You can see either as you please,

and the contesting of the one by the other: this is already a metamorphosis. And here is a tiny little man in the hands of a giantess. Look at him: he is leaning up against a rock, the whole of the Titaness becomes a rock; her back, her powerful shoulder-blades are petrified. Now raise your eyes and look at the giantess herself. The semblance of petrification disappears; all is movement and there is no Titaness any more: a woman is soaring skywards. Similarly, these enormous hands holding tiny women represent the ambiguity of the human condition rather well; look at them: the woman becomes a statuette, an amulet, an inert plaything. Look at the woman: her hands stiffen, they are marble hands, mere material supports. And it is our eye that operates the transubstantiation, our eye that leaves the flesh haunted by the memory of marble and the marble by a ghost of animal warmth. Everywhere we find thwarted, disappointed expectations, a deliberate transmutation of sensations: this sexual organ explodes, this head bursts into bloom, this female body trails off into a fog and the fog bleeds. Nowhere has Masson handled lines better, nowhere has he better lightened his outlines, made them mobile; nowhere are the slidings and swirlings of his surfaces more palpable. He is the perfect master of his mythological technique.

It is for this reason that he will abandon it. He doesn't know clearly, when he makes them, that his drawings are farewells and yet he isn't entirely unaware

of it. He feels he has perfected his craft: it was a solution
to his problem; he has to find others, he cannot content
himself with a happy find which, once perfected, runs
the danger of degenerating into a mere procedure. As a
painter of movement, his art must itself be movement.
He has a clear insight into what he is doing, now that
he is no longer diverted by the difficulties of execution
from seeing himself, and he discovers that his mythology
is 'rigged': there is more here besides the drawing; it
combines with significations that reach beyond graphic
art; to animate his engravings or canvases Masson notices
that he has resorted to symbols. To communicate a trou-
bling softness to his female figures, to make us feel one
sinks into them, he has used mist. That is to say, he has
used all the associations of ideas and feelings that fog
evokes in the viewer. He has only partly traced the out-
line of this misty woman: she is an open figure. But if
he has given up the line, if he has cast off the brush-
stroke, this is because the misty substance he chose to
paint gave him permission to abandon them. What if he
gave up the guard-rails and safety-nets—all these pro-
tections by which his art is still hemmed in? What if, by
simple decree, he rejected outlines?

He had, in fact, been patiently trying to wear
them down for a long time. Between 1940 and 1947 he
tried to eliminate their value and their function while
persisting in drawing them: let them remain on the
canvas or the paper if they like, but they are to stop

signifying finitude. 'All determination,' said Spinoza, 'is negation.' It is this negation Masson is attempting to deny. Sometimes he scores the interiors of the bodies with thick lines, at the same time as he thins to the ultimate degree the external trace that delineates their shape: the accent is then put on substance and the furrows, striations and dividing lines look like internal movements of the flesh while the outer line that delimits that flesh—thin, dead, inert—seems an entirely temporary halt to its expansion.[10] At other times, the creature will spurt up from the earth in a kind of spiralling and the outline, knotted back on itself, caught in this live coiling, sticks to it, spirals with it and, far from looking like a barrier raised against the internal forces, seems drawn towards the 'inner space'.[11] At yet, at other times, he will cover his drawing with tangled curves, hatchings, fleckings: and the outline properly so-called, lost in the middle of this forest, devoured by the greenery, will lose both its autonomy and its discriminative function. Is it one of the countless crossed lines that depict the 'inside' of the face or one of those making up the background? Without abandoning it, he eliminates the graphic form by excess. During this time, by an osmosis occurring through this flimsy, impotent membrane, the background will penetrate into the form and the form will seep into the background. Even more boldly, he will double the outline

10 *Portrait de Georges Limbour*, 1946; *Sur le point de parler*, 1946.
11 *Au travail*, 1946.

and paint a face as though projected out in front of itself. It is the form this time that begins to break up and wrest itself from itself. One further step remained: it has now been taken. From 1948 onwards, the outline gives way; living substance breaks out of its shells and spreads across the picture. There is nothing left to stop Masson revealing his myth in all its Dionysian purity. 'If a leg falls into the sea,' the Stoics said strangely, 'the whole sea becomes leg.' In his latest canvases, legs, thighs and breasts fall into the sky, into the water: all the water, all the sky, the walls and the ceiling become breasts or thighs. The mythology is now redundant: there is no need to draw a mountain as a twisted, muscular leg any longer, since everything is in everything, the leg in the mountain and the mountain in the leg. 'Imagine a head of hair compared with a waterfall . . .' he wrote in 1947. But if he wanted to transform the waterfall into a head of hair, it was so as to make it more of a waterfall, so that the sensual impact of disarranged hair would make us feel the gentle, restless voluptuousness of the falling water. These comparisons are no longer necessary now. We do, admittedly, still see metamorphoses. But no longer the successive phases of a bird changing into a man: the metamorphosis is now that of something changing into a bird. 'I heard,' wrote Conrad one day, 'a rattling . . . muffled sounds . . . it was the rain.' This is what Masson wants to paint now: neither the taking-flight nor the pheasant, nor the pheasant taking off, but a taking-flight that becomes a pheasant. He goes into the field and a flare explodes in the bushes:

this pheasant-explosion is his picture. He has retained everything of his earlier experimentation, but arranged everything in a new synthesis. Only now is it the time for us to look back at his 1947 drawings; only now can we understand them.

In 1947, they were simply a perfect accomplishment that seemed complete in itself: this was Masson's very own style, which had its limits and its outlines. Today, the engravings explode and they move us because we can see heralded in them, uncertainly as yet, a new and different approach.

Introduction to André Masson, *Vingt deux Dessins sur le thème du Désir* (Paris: F. Mourlot, 1961).

<div align="center">✳</div>

FINGERS AND NON-FINGERS

I got to know Wols in 1945.[1] He was bald and had a bottle and a knapsack. In the knapsack there was the world, his concern; in the bottle, his death. He had been handsome but he wasn't any longer: at thirty-three you would have taken him for fifty, were it not for the youthful sadness of his eyes. No one, himself included, thought he would live to a ripe old age. He made this clear himself on several occasions, taking no satisfaction from it, to point out his limitations. He had few plans: he was a man who was always beginning again, eternal in every moment. He always told you everything right off, and then he told you it again differently. Like 'the little waves of the port/that repeat without repeating'.[2]

His life was a rosary of battered beads, each of which embodied the world; the string could be cut at any point

1 The pseudonym of Alfred Otto Wolfgang Schulze (1913–1951). [Trans.]

2 From a poem by Wols.

without doing any harm—that was how he put it. I now believe he had thrown himself into a short-term project, a single one, which was to kill himself, being convinced you can express nothing without destroying yourself. The bottle makes its appearance very early on in his drawings. He wasn't proud of this. Though sick and poor, stoicism and voluntarism were totally alien to him; he wasn't even contemptuous of his miseries: he spoke about them, rarely, but unrestrainedly—with a great deal of distance and a degree of collusion. To put it more accurately, he found them normal and, when all is said and done, insignificant. His real torments lay elsewhere, in the depths of him.

He couldn't get over the fact of belonging to our species: 'I am the son of man and woman, or so I've been told; that surprises me . . .'[3] He treated his fellow humans with a suspicious courtesy, preferring his dog to them. In the beginning, we hadn't perhaps been without interest, but something had got lost along the way. We had forgotten our *raison d'être* and launched ourselves into a frenzied activism which he, with his usual politeness, called 'scheming'. His nearest and dearest themselves remained so alien to him that he could work right there among them, despite their shouting and yelling. A coral among corals, he lay down on his bed, closed his eyes and the image 'gathered in his right eye'. He sketched crowds that are animal colonies: the people touch each

3 This is a line from Comte de Lautréamont which he made his own.

other and perhaps smell one another; they certainly do not see or speak to each other, absorbed as each of them is in a solitary gymnastics of elongation. He had every reason to bear a grudge against us: the Nazis had driven him out, the Falangists had put him in prison, then expelled him, the French Republic had interned him.[4] But he never said a word about this and never, I believe, gave it a thought: these were our 'schemings' and they didn't concern him. Generous without warmth and attentive out of indifference, this princely tramp pressed on with his fruitful suicide night and day. At the end, his friends had to carry him, each day, to the Rhumerie martiniquaise and bring him back in the middle of the night, a little more dead each day, and each day a little more visionary. And why not? That is living.

When he opened up his bag, he pulled out words, some found in his head, most copied from books. He made no distinction between the two, though he scrupulously insisted on putting the author's name at the foot of every quotation: there had, after all, been an encounter and a choice. A choice of thought by man? No, in his view, it was the other way about. Ponge once said to me at about this time, 'One doesn't think, one is thought.' Wols would have agreed with him: the ideas of Poe or Lao-Tzu belonged to *him*, insofar as they had never belonged to *them*, and insofar as *his* ideas didn't belong to *him*. What were they about, these twenty-four maxims

4 From September 1939 to October 1940, Wols was incarcerated as an 'enemy alien'. [Trans.]

he carried around with him? Like his gouaches, about absolutely everything. Torn out of a book or from an individual's speech, cut adrift from all the surrounding circumstances, they seemed infinite or, rather, indefinite, unless one took the view that Wols was to be found in them *in person*. He was very attached to them. Though less than to the products of his paintbrush: for one thing, he was distrustful of words, those 'chameleons'. And rightly so. And yet we have to trust them or write nothing. His poems are not especially inspired. Above all, I sense that he used language to *reassure* himself: hardly any of the chosen phrases is without a little flash of mystery; the gilded verses of a white pantheism serve as commentaries to the blackest of works. He escaped horror by speaking. He knew this, I think. He left more than a hundred and fifty pictures, thousands of gouaches and two dozen maxims—never changed—which he had taken for his own in what were perhaps happier times, if he ever had any happier times. Before his detox, which came eight months before his death, he was starting to become muddled in his speech. He would sit down beside me in the morning, talk confusedly, become irritated, groan and suddenly pull out his little black book, place between us the wisdom of Lao-Tzu or the Bhagavadgita and calm down immediately. The sentences floated before my eyes, dead and inert; they were the lifebelts of this slumberous, tragic genius. Though truer to himself than anyone I have known, no one more roundly made me feel that 'I is another'. He was suffering; his thoughts and

images were being stolen from him; atrocious ones were being put in their place and they filled his head or gathered in his eyes. Where did this come from? From what childhood? I do not know. The only thing that is sure is that he felt he was being manipulated. I have never been able to look at *La Pagode* [The Pagoda], his gouache of 1939, a self-portrait of the painter, without thinking of Sherrington's experiment: that dog's head, cut from its body, but artificially perfused, just about surviving on a tray. Though not severed from his body, Wols' head was just as pained: the eye is closed; and there can be no doubt he is being used in an experiment: wires, membranes and clusters of pipes driven into his skin plug the sleeper into an entire little world—a butterfly, a horse, cockroaches, a violin, etc.—which he suffers, unseen, *from the inside* and which inflicts his sleepwalking on him. *Le Pantin* [The Jumping Jack]—another self-portrait—one-armed and open-eyed this time, seems to be activated by a strange, complicated, antiquated apparatus that regulates his movements and his vision *from behind*: from the top of a post, a circus strongman oversees operations. Tormented, hounded, haunted by woodlice and cockroaches, he could do nothing but give himself up unreservedly to these simple hallucinations and transcribe them there and then. He hesitated over the results. He was in no doubt that he had to give them all he had. But would they be beautiful? Recopied in his own hand, these words of Maeterlinck show that he was still trying to hope:

If the matter on hand is the making of a pipe, the shoring of a tunnel, the construction of cells or boxes, the building of royal apartments . . . the plugging of a chink through which a thin current of air might penetrate or a ray of light filter—these being calamities to be dreaded above all—it is again to the residue of their digestion that they have recourse. One might say that they are first and foremost transcendental chemists whose learning has triumphed over every prejudice, every aversion; who have attained the serene conviction that nothing in nature is repugnant, that all can be reduced to a few simple bodies, chemically indifferent, clean and pure.[5]

Did he really share this serene conviction? On some days, yes, he wanted to share it. Pantheism, whatever form it takes, is the permanent temptation of the possessed: they are inhabited, the cockroaches run around at night from kitchen to attic; the enemy is in solid occupation of the cellars: they will escape that enemy if they blow up the building or if they plunge themselves into the Great All. Being different anyway—it is their lot to be so—they will substitute the being-other of substance for that of the finite mode. Wols, that proud termite, built palaces from his droppings, by order. The beast

5 Maurice Maeterlinck, *The Life of the White Ant* (Alfred Sutro trans.) (London: George Allen & Unwin, 1927), p. 71.

dreamt of his own decomposition, along with the decomposition of his products, dreamt that nothing would remain of either but the original purity of their elements. His gouaches bear witness to this: they are frightening and they are beautiful. But one cannot decide whether the beauty is a promise or the ghastliest dream of the termite's nest.

Klee is an angel and Wols a poor devil. The one creates or recreates the marvels of this world, the other experiences its marvellous horror. All Klee's good fortune conspired to create his one misfortune: happiness remains his limitation. All Wols' misfortunes gave him his single piece of good fortune: his misery is boundless. Yet it was in Klee that Wols recognized his own self, when he was about nineteen years old. Let us say, rather, that he found lights in Klee's work and projected them on to his own darkness: those lights illuminated a swarming and wriggling that already troubled him and, phantasmagorically, covered over with human significations the spontaneously inhuman meaning of his original intentions. If we want to retrace the path he followed, we must start out from Klee.

'The artist,' said Klee,

> is better and more subtle than a camera, he . . .
> is a creature on earth and a creature in the
> Universal: a creature on a star among the stars.

These facts progressively manifest themselves in a new conception of the natural object . . . that tends to become totalized . . . By our knowledge of its inner reality, the object becomes much more than its mere appearance . . . Beyond these ways of considering the object in its depth, other paths lead to its humanization, by establishing between the 'Thou' and the 'I' a relation of resonance that transcends any optical relation: first, by way of a common rooting in the earth which, from below, conquers the eye; second, through a common participation in the cosmos which comes from above. Paths that are metaphysical in their conjunction.[6]

The artist refuses to *anatomize:* however rigorous the analysis, it merely expresses the inevitable 'natural' illusion of a subject that regards itself as absolute, with no ties or limitations. Klee is too much the realist to accept that the pure void becomes a gaze and that objects parade, like fashion-models, before an invisible lorgnette. Whatever the objects of his attention, the painter will not make them say what *they* are without thereby learning what *he* is. The sea which, from twenty thousand feet and at six hundred miles per hour is hardened, frozen and shrivelled, damns with the denunciation of its secret

6 Paul Klee, *The Thinking Eye. The Notebooks of Paul Klee,* VOL. 1 (Jurg Spiller ed., Ralph Manheim trans.) (New York: G. Wittenborn, 1961), pp. 63–7. [Trans.]

solidity the aircraft whose speed leaves it behind. The whole of the sea is aircraft, the whole aircraft is sea. This reciprocity of reflections will be crushed on a canvas; the sky and the earth will plunge into its abyss, dragging human beings down with them—those solitary voyagers revolving around a spinning planet. This is the place: this is where an organic—or, as Klee puts it, 'physiological'—painting is born. The painter and his model belong equally to the totality that both governs their true relations and is, on the other hand, entirely embodied in each of them. The object reveals itself in its functional relation to the world and, at the same time, reveals the artist in his physiological relation to the indivisible whole. The Seer is something seen; his Seeing is rooted in visibility. By contrast, the artist gives that which he does not have—his being. No sooner does he project it outward than this lacework of shadows is reflected back by the ribs and veins of the object. And this plastic object, by its ambiguity, achieves a shared rootedness in the earth, a shared participation in the cosmos; it unites the 'Thou to the I', revealing, by way of the other, the presence within each of that notable intruder, the Whole.

Wols' gouaches of 1932 can be cited as sufficient proof that he came to a discovery of himself through ideas of such purity: in them he is a creature on a star, reproducing other equally astral creatures; he has understood that the experimenter is necessarily part of the

experiment and the painter necessarily part of the picture. A little later, he gives *The Circus* a significant subtitle: 'Simultaneous Filming and Projection'; these lines by Klee could serve as a commentary to it:

> All paths meet in the eye, at a point of convergence from which they are converted into Form, to end in the synthesis of outer gaze and inner vision. At this meeting point are rooted forms shaped by the hand that are entirely distinct from the physical aspect of the object and yet which, from the standpoint of the Totality, do not contradict it.

This is a text which Wols seems to be trying to illustrate in 1940 with his *Janus Bifrons Carrying the Aquarium*. Here, the circus tumbler has two faces, two pairs of eyes, simultaneously seeing the world in front and a world behind; the union of these two views is effected somewhere outside by the hand of the monster that is busy choosing a head from inside its portable fish tank. Yet this gossamer universe, studded with its suspect, transparent areas, is not Klee's world: it is frightening. And then, can the artist *see*? Janus' eyes are blank. He seems to be being led: a cockroach is tugging at his sleeve. The foul beast is doubtless going to force him to choose a cockroach.

The affinities will seem clearer and the disparity the more marked in those gouaches of his youth that claim

to show our 'shared participation in the cosmos'.[7] There can be no doubt that Wols was attempting here—as in each of his works—to present both the world and himself in the form of other creatures. But he turns his attention, this time, to heavenly paths. His angelic master often took this route: 'The higher path involves the dynamic order . . . It is the aspiration to free oneself from earthly bonds that leads on high: one is striving to attain an unfettered mobility beyond that of swimming or flight.' Wols takes his inspiration from this, but, if we look at them closely, his bottle imps are very far from moving freely. Klee's little figures enjoy a spontaneous weightlessness; at other times, 'a little genie holds out his hand' to draw the artist into a celestial region where 'objects fall upwards'. There is nothing of that kind here: neither outstretched hand, nor reversal of gravity. For this 'Sylph of the Cold Ceilings', one may rise up but one cannot escape the earth's attraction. His little figures rise and fall as the current takes them, light but inert, some way short of the liberty afforded by swimming or flight. Around 1939, they will disappear. By contrast, the 'shared rootedness' will increasingly assert itself. It is that rootedness that will integrate the upward aspiration into itself; that aspiration will become the upward thrust of his tied-down crowds, solitary marshmallows, stretching out in vain towards the zenith. Above their heads, as a last incarnation of 'unfettered mobility', is a teeming of

7 Cf. *Les ludions* [The Bottle Imps], 1932; *Tous volent* [All Fly], 1937.

flies, fleas and flying bugs, of floating pustules, jumping beans and spider's threads. This horrible swarm mocks the efforts of the human plants to shake off their roots. Rootedness, impotence, horror and vain desire—these shadows, slowly accumulated in a crystal paradise that they are going to explode, are Wols discovering himself 'in person' through the work of Klee.

We can see at a glance what the two artists have in common. Both are totalitarian and cosmic. For each of them, the plastic arts perform a function of ontological revelation: their works aim without exception to pin down the being of their author and the being of the world in a single movement. And there is no doubt, with each of them, that there is an underlying religious experience to this. But this very experience separates them: they didn't undergo it in the same way nor do they share a common conception of the 'prehistory of the visible'.

Klee justifies his totalitarian realism by an explicit recourse to Creation: 'The being [of the fundamental things of life] . . . lies in the precise function they perform in what we might still call "God".' Moreover, of the artist he says:

> His progress in the observation and viewing of nature leads him gradually to a philosophical vision of the universe that enables him freely to create abstract forms . . . In this way the artist creates—or takes part in the creation of—work that is in the image of the works of God . . . Art

[is], as a projection of the original supra-dimensional ground, a symbol of Creation. Clairvoyance. Mystery.

The painter and his object communicate at the deepest level; they are produced, sustained and integrated into the totality of being by the synthetic unity of an act which they both *are* and perform, at the same time as *it* makes *them*: the All is the manifold sign of a single *fiat* which the artist encounters in himself as the source of his existence and which he continues through his work. The fundamental thing remains *praxis*, and being is defined as the functional relation of the parts to the continuing Creation by which they are totalized. In this sense, Klee's mysticism is the very opposite of quietism and Jean-Louis Ferrier is right to call it an 'operative realism'. If everything is actual, active and perpetually reactivated,

> the door is open to exact research . . . Mathematics and physics provide the key in the form of rules to be observed or avoided . . . these disciplines impose the salutary obligation to concern oneself first of all with the function and not to begin with the finished form . . . one learns to recognize the underlying forms; one learns the prehistory of the visible.[8]

8 Paul Klee, 'Exacte Versuche im Bereich der Kunst', *Bauhaus. Zeitschrift für Bau und Gestaltung*, 2(2/3) (1928). [Trans.]

It might be thought that Wols was responding to the words I quoted above—'what we might still call "God"'—when, in *Reflets*, he writes: 'It is superfluous to name God or to learn something by heart.' The whole difference between the two men can be seen here. Though free of all catechisms, Klee nonetheless retains a Christian, Faustian view of the universe: *Im Anfang war der Tat.*[9] This is not the case with Wols. This sorcerer of being begins by rejecting the Act: 'At every moment, in every thing, Eternity is present.' Then he rejects the *Logos*: 'The Tao that can be named is not the real Tao.' Art crumbles to dust at the same time as its guarantee, divine Creation. Wols' realism will not be 'operative', because any kind of operation is repugnant to him: after his first attempts, he will give up painting on canvas for many years (twelve in all). 'It's ambition and gymnastics, I don't want it.' What he condemns in any undertaking is not simply the plan and the execution, but also—and above all—the construction, the style and all the forms of interpretation and transposition: 'When you see, you mustn't focus eagerly on what you could do with what you see, but see what *is*.' The plastic object is increate, insofar as the eternal is manifested in it. So, there will be no composition: vision will of itself make itself visible, since seeing and showing are one and the same thing. This fierce invalid begins by amputating his practical reason: 'Not to do, but to be and to believe.' There is

9 'In the beginning was the deed', one of the most widely quoted lines from Goethe's *Faust*. [Trans.]

only one choice to be made: to squander one's energies in 'scheming' or to gather oneself into a still waiting. By denying Being that virulence which, in Klee's hand, brings it close to a pure act, is Wols opting for a contemplative quietism? In fact he is not, but rather for that introverted *praxis* I term passive activity. His infinitives are disguised imperatives: we are, and yet we *must* be. He liked to cite the following maxim from the Bhagavadgita: 'All existences obey their [own] nature.' Here 'ought' merges with 'is' and nature with norm. Klee's 'philosophical vision' gives way to *the metaphysical attitude*. One *assumes* an attitude and one *retains* it. Through this tension, Wols will generate the inflexible law that both governs and remains alien to him. It is a contradictory striving: he both raises himself up—hence the endless teeming of phalluses in his gouaches—and overdoes obedience, so as to efface himself, and so that the heteronomy of his will disappears with him. This is a recipe for dissension: the eternal rends immanence asunder, explodes our categories, 'Thou' and 'I', subject and object. To be is to 'see what is', to discover one's nature in the being of the Other. And to see is to be: the being of the Other appears only to the Being-Other of one's own inwardness.

It is also to *dream*: 'the experience that nothing is explicable leads to dreaming.' Not the experience, but the lofty refusal to explain, to break down being into causal series that reach back *ad infinitum*. Entire and

gathered together, Wols welcomes the inexplicable, which is whatever comes; on each occasion, the world is embodied in it. Fully. So, to dream is to see. 'They who dream by day are cognizant of many things which escape those who dream only at night.'[10] They see being, that ambiguity of things, and it matters little to them whether it appears from the outside—root, potsherd, pebble or paving stone—or wells up from their inner-most depths to 'accumulate in their right eyes'. What counts is opening oneself up, waiting, grasping the ungraspable or, rather, being seized by it. And then, if need be, fixing it, without moving—or almost: 'You have to squeeze the space up more tightly.' The inner vision will externalize itself on to 'a tiny little sheet' by an imperceptible agitation of the fingers. An imaginary thing shows on the surface of the paper: the *manner of being* of a cryptogam, a passion, a woodlouse, Wols or the world—all indistinguishable from each other.

The being of the part resides in its relation to the whole. Klee says the same thing, but, colluding in Cre-ation, he argues that this relation is a practical one: the part 'works' in an ongoing totalization and the philoso-pher-artist lucidly plays a part in the permanent unifi-cation of reality. Wols knows nothing of unification: he

10 Wols quoting Edgar Allan Poe from the short story, 'Eleonora' [first published in the 1842 edition of *The Gift: A Christmas and New Year's Present*, an annual publication; reproduced in G. E. Woodberry and E. C. Stedman (eds), *The Works of Edgar Allan Poe, Volume 1: Tales* (Chicago: Stone and Kimball, 1894–95), pp. 203–11—Trans.]

'has in his sights a path towards unity'. That *unity* is *already* there and always has been. But totalization is there none: the Whole hangs in the air, alone, finished, never begun. He refuses to see the synthetic relating of the detail to the totality as an active, dynamic participation in the universal project. It is a stable structure of reciprocity: the part cancels itself out in favour of the whole; in each part the whole is embodied and imprisoned. Being yields itself up through this dual relation: neither shifting nor stable, eternity is erected in advance; it is a force that is suppressed as it produces and maintains inertia, an inertia shot through with the horrible dream of acting.

For Klee the world is, inexhaustibly, to be made; for Wols, it is made—and with Wols in it. Klee, active and a 'computer of being', comes to himself from afar; he is himself even in the Other. Wols suffers his own being: that being, which is other than himself even in the very depth of himself, is his being-other; external things reflect this back to him to precisely the degree that his—unnameable—inside has projected it on to them. He quoted me once: 'Objects . . . touch me; it is unbearable. I am afraid of coming into contact with them.'[11] It matters little here what these words mean for me: what *he* means is that objects touch him because he is afraid of touching himself in touching them. They are himself outside of himself: to see them is to dream himself; they

11 Sarte, *Nausea*, p. 10. [Trans.]

hypnotize him. Kelp and hart's tongue reflect his nature back to him; he deciphers his own being from the knots in a piece of bark, from the fissures in a wall; roots, rootlets, the teeming of viruses under a microscope, the hairy furrows of women and the turgescent flaccidity of male fungi compromise him; he finds, in them, that he is fissure, root, hart's tongue and kelp. By contrast, when his eyes are closed and he withdraws into his own darkness, he experiences the universal horror of being-in-the-world; the vile hatching of a wart in stone, the crabbedness of a larval flora and fauna, accentuated by the impossibility of rejecting existence—everything accumulates in that retina of his which is steeped in darkness. These are two paths that are but one: fascination and automatism. He is spellbound by external objects when they seem to him like products of his *écriture automatique*; his automatism is merely the spellbound attention he devotes to his own products when they present themselves to him as external objects.

For the 'horrible workers' whose 'I' is an other, being is defined by otherness: it is in the nature of things not to be what they are.[12] Up to 1940 or thereabouts, Wols took familiar figures from the tangible world—men and women, plants, animals, doors, houses and towns—and applied the principle of non-identity to them. His aim was not to breathe life into this imagery but to unsettle

12 The phrases 'horribles travailleurs' and 'Je est un autre' are taken from Rimbaud's letter to Paul Demeny of 15 May 1871, first published in *Nouvelle Revue Française* (October 1912). [Trans.]

it. A single subject treated a thousand times: the fixed shimmering of the elusive, both manifested and hidden in the uncertain relation of part to whole and of whole to part, in the double incompleteness of the One and multiplicity. In these rigorous, complicated little systems throng forms whose careful individuation merely underlines their radical indistinctness: they offer themselves to the gaze, the better to elude it; each is in contact with all, directly or through one of the countless transmission belts striating the gouache. As for localizing the point of contact, that is impossible: one can barely determine more or less extended zones where the contact probably takes place. Taken in isolation, each thing changes, immutably, into its opposite; each one affirms and denies itself simultaneously; the composition runs out of steam and falters: it is decomposition interrupted. A particular densely painted patch imposes itself, then straggles off in a spidery rumpling of threads; it 'takes light' the way a leaky boat 'takes water' and then tightens again, dark and impenetrable. Yet nothing has moved, except our eyes. On this stake, at its upper edge, an athletic figure is impaled; this is the pointed crown of a pillar that sits heavily on the earth; from the eye's lower edge, we see it come apart halfway down: farewell to weight and gravity; it ends in bamboo tubes bound together with string. In *The General and His Family*, the three figures are floating, falling and walking all at the same time in a suddenly emergent space that has both a continuity which unites them and inner divisions that separate

them forever. The son has a bloated, full face: a head-of-hair-that-becomes-a-nose, a buccal proboscis; importance puffs up his cheeks, dulls his little elephant eye and then, suddenly, there is nothing—a wreath is wound around the empty space and, inside, the eye vanishes, unfinished perhaps, or swallowed by that omnipresent gap, the sky.

Despite the beauty of his gouaches, Wols is still simply a virtuoso of prestidigitation. So long as he uses those most magical of objects, the human face and the human body, then he will be able, in whatever way he distorts them, to trick us at will. If he relies on our habits, summons up our commonest expectations, our nocturnal fears, our desires, if he evades or deflects our attention with sham and pretence, then these deceitful analogies will bring us up against impossible syntheses, which we shall continue to assent to, despite having recognized their impossibility. This is the three-card trick, the prestidigitator's force of suggestion. There is no deliberate intention to deceive; no one has less of a method, as I have said, than the author of these *trompe-l'oeil* works: he simply shows what he sees. Nonetheless, around 1940, he developed a distaste for his way of seeing: to reveal the 'supra- dimensional, trans-optical foundation' of things and depict it in images, the visionary has to apply himself to seeing—and, hence, to being—more profoundly. Wols' *attitude* became radicalized. Yet he would never entirely give up drawing towns, people, animals and plants: what changed was the function he

assigned to them. Earlier, he used everyday objects to construct traps, to suggest the 'ungraspable' as something that lay beyond their contradictions. After 1940, with different means employed to call it up, *being* appears first and those objects are suggested allusively. Everything turns around: being was something one divined; it was the flip-side of man; now, it is man that is the flip-side of being. Let us re-open Wols' bag and filch this further quotation from it:

> Taking fingers to illustrate the fact that fingers are not fingers is less effective than taking non-fingers to illustrate the fact that fingers are not fingers. Taking a white horse to illustrate the fact that horses are not horses is less effective than taking non-horses to illustrate the fact that horses are not horses.

> The universe is a finger. Everything is a horse.

For anyone attempting to understand them through their author, Chuang-Tzu, these remarks remain fairly obscure; they do, however, become clear when related to Wols' work, and cast a new light on it.

There are two ways of illustrating the otherness of being. The first of these is to reveal, in a finger, the cancerous presence of Everything. Dubuffet excels at this: he paints women as pink purulences, as glandular, visceral blossomings, as honest, hard-working beasts with a meatus, two breasts and the fine stripe of the sex. They

are non-women, a purely organic entity, its swathing of myth stripped away, a naked palpitation on the surface of inorganic matter. Wols set off down this track at first, but he did not have Dubuffet's powerful, harsh materialism to sustain him: the microscopic structures of matter fascinate him, as we know, but they do so because of the being they attest to. As a result, he will have little difficulty changing tack in 1941 or thereabouts, and moving on to his second style—revealing the being-other of the finger by deliberately painting non-fingers. Non-fingers whose being-other will indeed be the finger—a finger never seen and never named, but always present. Is he going to go back to Klee again? To attain: 'the philosophical vision of the universe that . . . enables one freely to create abstract forms'? Yes and no. The universe is certainly in question; and experience, revealing the nature of things to Wols, enables him to embody the world in objects that are not met in the world. But, more faithful than ever to automatism, both before and after 1941 he rejects the name of creator or artist. An exhibitor of shadows or of being—those are his titles. These new figures are, no doubt, imaginary. But the imagination is not creative: in the metaphysical attitude, Being becomes its law, it is the mere plastic objectivization of that Being. Moreover, its products *are*: they manifest the strict equivalence of Martian fauna as it might appear to the members of our species, and of the human race as it might appear to Martians. As both man and

Martian together, Wols strives to see the earth with inhu-
man eyes: it is, he thinks, the only way to universalize
our experience. He would not, admittedly, call the
unknown—or too well-known —objects that now figure
in his gouaches 'abstract forms', since they are as concrete
for him as those of his first period. This comes as no sur-
prise: they are the same in reverse. He has, for example,
retained the stretched-out character of his forsaken
crowds; only it is no longer human beings that are
stretched out, but unnameable, rigorously individuated
substances that symbolize nothing or no one and seem
to belong simultaneously to the three kingdoms of
Nature—or perhaps to an as yet unknown fourth one.
Yet they do concern us all the same: being radically
other, it is not our lives they manifest to us, nor even our
materiality, but our raw being, perceived from the out-
side—though from where?—without complicity, alien,
repellent, but *ours.* It is impossible to view this being that
we are without a sense of dizziness, this being that is cap-
tive in these substances like the being that they are.

If being-other is the law of being, it will not be so
hard to show that a finger is not really a finger, that it
betrays its essence in every way: we know that essence,
but how is it with the non-fingers, those unknown
objects of which we know nothing? How can we perceive
that *they* are other than themselves? How does Wols go
about making us feel this? This question is directed at
writing itself and it is writing that will supply the answer.

We come now to a gouache, *The Great Burning Barrier*[13] that I cannot view without a sense of anxiety. Let us examine it.

Space has become more sober here: this continuous, three-dimensional, very respectably Euclidian milieu has rid itself of the cleavages, the dark dungeons, the cavings-in, the multifarious curves that cross-hatched it in the earlier period. And necessarily so: as long as the people had human faces, the onus was on the space to unsettle them. Now the container must seem all the more familiar for the fact that the content is so much less ordinary: the Thing comes to us, unnameable, through the realist space in which we believe we live; it asserts thereby that it belongs to our world: when the trap has closed again, we shall notice, too late, that the being's virulence gnaws at the frame that was lent to it: so long as it is *nothing*, the void is itself for as far as the eye can see; it alters as soon as you fill it.

Here, the Thing is red. At first glance, you would think it was painted wood. Red oxide. Pastilles of blood. An open-work fence. Or a fence blown to pieces—by a bomb or by time. Planks nailed to posts, rough-hewn tree trunks. Beneath this makeshift barrier, other trunks lie unused. This initial sense breaks down almost at once: the shadows, a gradual alteration of the colours and the movements forced upon our eyes effect a transformation and turn the dead wood into stone. This horizontal creature,

13 The title of this gouache from 1943–44 was not chosen by Wols.

half-way up the gouache is, without a doubt, ligneous in nature. But now it breaks off at ninety degrees and forms a right angle: a wooden leg looms out at us. But it is not wooden. Grey and grey-green flecks betray the mineral essence of the enormous foot on the end of it, which twists round towards the right. Where did the transformation occur? Everywhere and nowhere. The lower part is a wooden beam, the higher part granite, but the undeniable unity of form compels us to *see* the unity of substance, cleverly denied by the internal evidence: a single entity forms and unforms simultaneously before our eyes. it is both rocky and ligneous, but there is no conflict: just a still wavering of matter, suspect at every point. All the more so as a sinuous creature, on the other side of the central axis (powerfully marked by a red, phallic upward thrust), smoothly takes over and extends the stiff, constrained movement of the stone ankle-boot and darts out towards the far right, with its pink belly and grey or grey-green back, a climbing plant or a crawling beast . . . No, that is going too far: it would be more accurate to assign it some pre-biological status. This time the forms are distinct, but the unity of values, colours and orientation drags the stony wood towards life, transforms its inert density into tension, revealing—with two white cavities and hairs that are suddenly clearly visible—that the stone ends in the rudimentary outline of a muzzle. The opposite is also true: the minerality on the left of the axis turns into dead weight; its passivity binds the creature on the right—conger-eel or

snake—in the chains of the inorganic. Every dead tree is a cliff, every cliff a leg; every leg is a reptile and all life, instantly paralysed, is merely an instantaneous process of petrification: being-other strikes immediately, crumbling otherness to dust. But let us be careful not to mistake for a method what has to be termed permanent transubstantiation: that is the law of this improvisation.

And here is the second law: everything is fixed, outlined, its contours are set; nothing either is or can be located in space. Substance has undergone some inward accident: in the places where the hue darkens, marking the increased density and thickening of being, the opaque matter resolves into translucency; through it we can make out the contours of the bodies it should hide, *does hide*. It is not the only effect of this artful play of transparencies to bestow a porous impenetrability on the visible; it also ends up jumbling the picture planes. A single object seems simultaneously *in front of* and *behind* the others, like this hooded monk—or unhooded male member— apparently walking slowly, to the right of centre, in the lower half of the gouache: how is he/it to be situated in relation to the recumbent figures? Is he/it in the foreground, the background or the middle distance? There is no answer to this question: by its emergence, the Thing produces a radical indeterminacy of location; it creates distant objects only to hurl them to the very forefront of the picture. And the identity of these entities is something merely approximate: are there two fallen trunks at the bottom of the picture or three? Is the rearing snake,

which hisses and sticks out its bent tongue on the far right of the gouache in front of the upright post, part of that post or separate from it? Everything is subtly constructed to render these questions futile. By imperceptible transformations of being, nearness takes a backward jump and becomes distance: the last fallen tree trunk seems right up against us over two-thirds of its length; on the other side of the post, on the right, the line becomes stronger and is braided with a chalky white; the object terminates abruptly; it is a cliff twenty leagues distant. In the dazzling centre of the gouache, the otherness intensifies; it is the crossroads of uncertainties: straddling forms, inert spurtings, transparent opacities, metamorphoses, dead wood, tumescent organs, knots of vipers—everything is hissing, everything is wresting itself from a rootedness that exists only as a result of the multiple effort expended on escaping it. In this monument of uncertainties, heaviness flies and inertia strains and tautens; nothing is certain, except that perfect precision leads to the most rigorous imprecision.

Right now, what do I see? First, allusions that make me think the universe is the right way up: these slashes in the stone are eyes, a wooden mouth opens, a one-legged man soars upward. But no, it is a crucifixion with two or three crosses, the recumbent figures are fresh corpses, I am witness to a slaughter, I catch three specks of blood on the rigid transparency of what is indubitably a male member—or, there again, it is perhaps a fire. But, to retain their consistency, these hints have to remain

marginal or one's eyes have to slide rapidly over the picture. Under examination, they contradict these impressions or are contradicted: the one-legged man was a mirage, I mistook this fire-coloured strip of unknown substance for the stump of a leg, the eyes are holes, mere gaps, exposed as such by other holes, which are almost like them but empty. Hardly have they substituted themselves for the crucified figures when a horrible bunch of rods, mushrooms and sea-serpents crumbles in its turn. These things never quite *are*. Summoned up and rejected by *contamination*, the allusion never raises itself to the status of signification; rather, it sinks in swells, beneath the skin, like a multiple meaning I cannot pin down. But, for the mere relation of meaningless proximity everywhere to produce false signs that devour each other in a permanent reciprocity of contestation, the apparent contiguity of forms has, in reality, to manifest the plastic unity of a whole. If I seek it out, this unity eludes me, but the details send me back to it constantly: by its incessant, congealed metamorphosis, it reveals itself as *integral to* a totality that is omnipresent in its absence, which is the Thing itself. There is the Thing, a materialization in *this* world, which comes to me, implicating me, in *my* space; and simultaneously there is that very world in which it unfurls itself, our world, which has now become an object for some unknown gaze, for *my* gaze. What *I*, the world's prisoner, see is, from the outside, the very world in which I have remained; it is I. I am the burning, bleeding other side of this thing that glows red. The

'vibratory disappearance' of allusions leaves me alone before this packet of ectoplasm, while at the same time conditioning my gaze: no, this sickening structure isn't a massacre or a martyrdom or a cauldron of hatred, but, since it is nothing else, hatred, misfortune, blood and anguish seem to me, through the fleetingness of these false signs, to be *its other meaning*. As though our human and cosmic condition—the condition through which we ordinarily sleep-walk—disclosed its unbearable horror only to eyes that have no connivance about them—naïve, alien eyes—or as though the truth of that horror were *my* being-other, raised within myself and ascending into my vision to alter it. I feel myself to be *over there*, a captive of the gouache and seen, with my comrades in hell, by a clear, demystified gaze; and at the same time I feel that I am *here*, in my own gaze, alienated from that of Wols, fascinated by his own fascination, as though his 'automatic writing' prompted an automatic reading within me. Inside and outside, angel and madman, other object and different subject: this ambiguity relates to me and, for that reason, is a persistent worry. All the more so as we are not speaking of an inert ambivalence that I could just register serenely. The two terms of the contradiction doubtless interpenetrate more than they are opposed, but since they cannot, in spite of everything, remain together, the Thing discloses to me—beyond action and passivity—its instantaneous imminence: *in a moment*, one of these two aspects of being will be absorbed into the other; this will mean *mental* alienation

unless a frosty, angelic gaze declares my alienation from the object; *in a moment*, either I shall be entirely alone and 'other' in this world or the world will confess its deep alterity: the asylum or hell on earth. *In a moment*: but in the moment—an over-ripe fruit that is always on the point of bursting—Eternity is embodied as the being-other of temporal succession; this suspended urgency is time caught in flight; it is time halted and it is the form-less sketching-out of a before and an after. For this rea-son, the Thing in the gouache eludes contemplation: to see it is to produce it and await it, to be torn between prior rejection and fascinated acceptance. In it Destiny becomes the being-other of Eternity.

That the finger is not a finger was what had to be demonstrated. Wols proved this brilliantly: by the non-finger. In so doing, he showed how he differed from the Surrealists, who had influenced him greatly. For the lat-ter, painting and poetry are one and the same; to paint 'melting watches' or to write 'soluble fish' or 'butter horse' amount to the same thing. We know the impor-tance they attach to titles; in their best works, words roll between canvas and paint like those puns that govern the phantasmagoria of our dreams: the Word is king. The superiority of Wols lies in the fact that the Things in his gouaches are unnameable: this means they do not fall within the ambit of language and that the art of painting has freed itself entirely from literature. Wols'

titles do not designate the object: they accompany it. To cite just one, what does *Pyrate Roots* mean? There is a play on words here, of course, but it happens after the gouache has been produced, and to one side of it: the work has produced its title, a vague reflection of a mood, of an inexpressible, forever obscure meaning. In short, the painter, with nothing in his hands or his pockets, allows himself to be frisked and relieved of all his words. To convince and to horrify, he has only the resources of the plastic arts: 'the five living pigments: point, line, surface, chiaroscuro and colour.' With these elements of form, in 'this little grey place where the jump from chaos to order can be successfully made,' he allows his forever-alienated thought to organize itself into the plastic thought of alienation. This vigilant, dumb automatism doesn't unleash itself in bolts of lightning; it is a directed ripening. And at last the object appears: it is being and it is the world, it is anxiety and the Idea, but it is, first and foremost, a self-improvised gouache whose only reference is to itself. It is all very well for Wols to mock Art and artists: by driving out literature, he condemns himself simply to draw more than ever on that sign-less writing commonly known as Beauty. Beauty, silent proof, cosmic unity of parts and whole: it is always the world— or at least a possible world—that is realized by beauty's particular density and by its rigour. So long as he is narrating, Wols relies on the familiar appearance of objects to persuade us. Afterwards, he employs one single, but constant argument: the Beautiful. Not one of

his gouaches is not beautiful. But this absolute end serves him as a means. Or, rather, if in secret he admits it is an end, this is because he has first belittled it and is using it; it is because he has made it the likeness of horror. Werner Haftmann is right to compare his gouaches to 'those creatures of an abominable beauty (one sees) in the aquariums of Naples or Monte-Carlo'. Though it is abomination, Beauty in Wols' work—that flower of evil—is never betrayal: it does not save; it attenuates nothing. Indeed, it reinforces the sense of anxiety since it is the very substance of the Thing, its texture, the coherence of being. The strict integration of forms and their marvellous, delicate hues are there to make manifest our damnation.

Preface to *En Personne: Aquarelles et Dessins de Wols* (Paris: Delpire, 1963).

✳

A NOTE ON SOURCES

'The Quest for the Absolute'

Originally published as 'La recherche de l'absolu' in *Situations III*, NEW EDN (Paris: Gallimard, 2003), pp. 215–26.

First published in English translation in *The Aftermath of War* (London: Seagull Books, 2008), pp. 333–54.

'Calder's Mobiles'

Originally published as 'Les mobiles de Calder' in *Situations III*, NEW EDN (Paris: Gallimard, 2003), pp. 227–30.

First published in English translation in *The Aftermath of War* (London: Seagull Books, 2008), pp. 354–60.

'Giacometti's Paintings'

Originally published as 'Les peintures de Giacometti' in *Situations IV* (Paris: Gallimard, 1964), pp. 347–63.

First published in English translation in *Portraits* (London: Seagull Books, 2009), pp. 517–39.

'The Unprivileged Painter'

Originally published as 'Le peintre sans privilèges' in *Situations IV* (Paris: Gallimard, 1964), pp. 364–86.

First published in English translation in *Portraits* (London: Seagull Books, 2009), pp. 540–74.

'Masson'

Originally published as 'Masson' in *Situations IV* (Paris: Gallimard, 1964), pp. 387–407.

First published in English translation in *Portraits* (London: Seagull Books, 2009), pp. 575–602.

'Fingers and Non-Fingers'

Originally published as 'Doigts et non-doigts' in *Situations IV* (Paris: Gallimard, 1964), pp. 408–34.

First published in English translation in *Portraits* (London: Seagull Books, 2009), pp. 603–41.